WINCHESTER

HISTORY YOU CAN SEE

WINCHESTER

HISTORY YOU CAN SEE

PENNY LEGG

For Mum and Dad, with love

First published 2011

The History Press
The Mill, Brimscombe Port
Stroud, Gloucestershire, GL5 2QG
www.thehistorypress.co.uk

© Penny Legg, 2011

The right of Penny Legg to be identified as the Author
of this work has been asserted in accordance with the
Copyrights, Designs and Patents Act 1988.

British Library Cataloguing in Publication Data.
A catalogue record for this book is available from the British Library.

ISBN 978 0 7524 5520 4

Typesetting and origination by The History Press
Printed in Great Britain by TJ International Ltd, Padstow, Cornwall

CONTENTS

ACKNOWLEDGEMENTS

I OWE THANKS to several people who have helped in the production of this book: Joe Legg, my husband; the Dean and Chapter of Winchester Cathedral, and Charlotte Barnaville, the Cathedral's Public Relations Manager; Suzanne Foster, Jeff Hynam and Jean Lambert at Winchester College; the staff at the Hospital of St Cross; Phil Yately from the Theatre Royal; the staff at Woolston library, Southampton, who are getting used to my bulk requests for books. I hope I have remembered everyone. If I have forgotten your name above, please accept my apologies and my sincere appreciation for your assistance.

INTRODUCTION

'Winchester, that grand scene of ancient learning, piety, and munificence.'

William Cobbett, *Rural Rides,* 1830.

WINCHESTER IS an ancient place. Its history can be traced back to before the Roman occupation, to a time four hundred years before the birth of Christ, when the Caer Gwent, the White City of the Celts, was a busy iron-age hill fort on St Catherine's Hill. The Belgae (the tribe from continental Gaul living near the Germanic border) and the Romans followed the Celts into the area. The Romans called it Venta Belgarum (the Market Place of the Belgae), as indeed it was. The Romans left little trace of their occupation; it is only from small clues that their presence in Winchester can be pieced together.

Moving forward, the Saxons made Wintanceaster (Winchester) great; it was the capital of Wessex. With the Saxon King Cynegils, who abandoned his pagan roots to convert to Christianity, the city became a religious centre. Saint Swithun and King Alfred came next to the city, carrying Winchester ever onward towards eminence.

During the time of the Norman invasion, William came to Winchester within a month of victory in order to claim the city from King Harold's widow, Edith. After he was crowned at Westminster, William the Conqueror came to Winchester at Easter each year to wear the crown and reinforce his dominance. William's victory led to the building of the Cathedral and the establishment of the Royal Mint in the city.

The Middle Ages saw the wool trade flourish and the Cathedral building refined. It also saw Winchester College being established, as well as the beginning of its decline from the great position it had occupied as a centre for pilgrimage. Pilgrims began trekking to Thomas à Becket's shrine in Salisbury, instead of the St Swithun shrine in Winchester.

The Reformation changed religious Winchester forever and the Commonwealth did its best to carry the destruction on, in both the religious and secular city. The Winchester of today is a respectable, genteel town with a proud heritage.

This book is not designed to be a detailed history of Winchester. Instead, it provides photographic perspectives that reveal some of the historical gems to be found in the city; sites that most people walk past with little understanding of their significance. It seeks to

explore the meaning of buildings and statuary and to investigate the streets and emblems that we see everyday but subconsciously overlook. I hope it will stimulate further study, as a volume of this size is not sufficient to do more than give the bare bones of the stories within it, or to cover every notable detail of Winchester.

My thanks must go to my long-suffering husband Joe, who, when I am busy researching and putting together a book, uncomplainingly comes along with me and gets to know the place I am working in. He has accompanied me on many of the fact-finding missions I have conducted for this book and has frequently offered his sharp eye for photography when out with the camera exploring the history that surrounds us.

Penny Legg, 2011

THE HEART OF THE CITY

THE CATHEDRAL and The Close lie at the heart of the city, so where better to start an exploration of the history to be found in Winchester than here? The Cathedral and The Close give testament to the power of the Church and its influence, both spiritually and politically, in the country.

Pilgrims arrived in the city via the King's Gate, which still stands to the south of the Cathedral. It was one of five gates into the city. It was built on the site of the original Roman South Gate and is intact, despite the loss of the walls either side of it. There is a small chapel upstairs, the 750-year-old Church of St Swithun upon Kingsgate, which is accessible from inside the gate on St Swithun Street. An amusing anecdote to our twenty-first century ears goes as follows: in 1660, the church was let to a man called Allen. He is thought to have kept his hogs at one end of the building, while his wife gave birth at the other! History does not record what his wife thought of this arrangement.

The first mention of the King's Gate dates from 1148, but the present vehicular access dates from about 1300. The twin pedestrian entrances are nineteenth century and the little house, built into the inside of the gate, is now a shop.

The entrance to the Cathedral Close from St Swithun Street is via Priory Gate; it is from the fifteenth century and the gates themselves are original. By the left-hand gate pillar is a Sarsen stone, a tough and relatively rare sandstone block. This was formed in a glacial period in Britain's history and was used as a bollard to protect the masonry. The porter shuts the Priory Gate (the entrance to the picturesque Dome Alley) every evening at ten o'clock.

The house immediately next to the gate is the Porter's Lodge. In the seventeenth century one of the rooms upstairs was kept for the 'Master of ye Choristers'. The house is part of Cheney Court, the collective name for the terrace of houses here. It is triple gabled with oak timbering up to the first floor, with flint and stone walls on the ground floor. The timberwork was covered in plaster in the nineteenth century. Cheney Court was the site of the ancient Manorial Court of the Bishops of

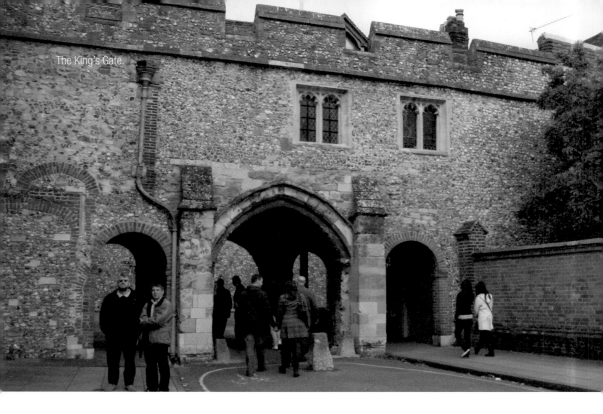

The King's Gate.

Below: Cheney Court and the old priory stable block. (By kind permission of the Dean and Chapter of Winchester Cathedral)

Winchester and, as such, it was under the Bishop's secular authority. He held judicial power over parts of the city until 1835. The house is now the home of the headmaster of the Pilgrims' School, just along The Close.

Adjoining Cheney Court, opposite the gate, is the old priory stable block. This is a two-storey, long, timber-framed building, which has been tree-ring dated to 1479. The upper floor was used for lodging guests who were not quite high enough in the pecking order for more refined accommodation. After the Dissolution of the Monasteries, the premises were sub-divided into six stables. It was partially renovated when the Pilgrims' School opened and again in 1957.

Mary Sumner (1828–1921), wife of the Archdeacon of Winchester, and the founder of the Mother's Union, occupied no. 1 in The Close with her husband George. She introduced the full-length windows upstairs on the first floor, in the drawing room, to allow more light into the dark room. The Mother's Union sponsored the two buttresses nearest to no. 1 when they were erected to help save the Cathedral from collapse.

King Charles' mistress, Nell Gwyn (1650–1687), is reputed to have wanted to stay in The Close, at no. 2, much to the consternation of Thomas Kell, the Bishop's chaplain. This embarrassed the old Wykehamist, who refused her permission. Poor Nell was forced to find lodgings elsewhere; she went instead to the extension of the Prior's house, which was added in the fifteenth century and still stands today.

Thomas Kell lived at no. 2, which was demolished about fifty years after Thomas' era, and for a time, kinsman

by marriage Izaak Walton (1593–1683) also lived in Dome Alley; this was after his daughter married canon Dr William Hawkins in 1676. Walton was the author of *The Compleat Angler*, first published in 1653 and, while living in Winchester, he also wrote a book of biographies called *Walton's Lives*.

The Deanery is a notable building. It was originally the Prior's lodging, as it was the Prior who ran the monastic Cathedral in the Bishop's long absences on official business. At the Dissolution, the Dean replaced the Prior and so the Prior's house, with its distinctive vaulted thirteenth-century porch, became the Dean's house, the Deanery. The house was rebuilt in the 1660s in brick, after Nicolas Love (1608–1682) had the medieval stone building demolished during the Commonwealth. At one time he was one of the two Winchester MPs (with John Lisle – *see* the Eclipse Inn – who was one of the judges who condemned King Charles I to death). Next to the Deanery is the Prior's Hall; it was built originally in the thirteenth century but then rebuilt in around 1459.

The Pilgrims' School

The preparatory school for choristers from the Cathedral and 'quiristers' from Winchester College, the Pilgrims' School, was a former canonry house used as the monastic guest hall. It is situated in The Close, in a mellow red-brick building that dates from the seventeenth century. It is known for its wainscoting, the fine oak interior-panelling that clads the walls and was made by Sir Christopher Wren's master craftsmen.

The school was opened in 1931 and the north wing is remarkable. The flint rubble walls give away its age, for the Pilgrims' Hall is a medieval building, which has a hammer-beam roof, said to be the earliest surviving in England. The school is set back from the street in what was known as the Outer Court, called Mirabel Close.

A walk around Winchester Cathedral is likely to take several hours, as there is much history to absorb. The Romanesque fabric of the Cathedral itself is a work of art and worthy of study. It displays the plainer, early Norman architecture and the more ornate, later construction; these are superb examples of medieval crafts-manship. The walls are packed with busts, plaques, monuments, memorials and flags commemorating those who have served the Cathedral, Winchester itself, or the country. The crypts are eerily fascinating. The antique chapels ooze a sense of times past and, amidst all the splendour and the quiet comings and goings of clergy, staff and visitors, it is easy to forget that this is still a place of worship; there are regular prayer and services throughout the day.

Christopher Brooke (writing in 1993) speculates that, from what is known about the building of the Norman Cathedral, it was probably constructed in two tranches. The first, possibly comprising the east end, choir, crossing and some of the nave bays, was started in about 1079 by its Bishop, Wakelin, the Royal Chaplain and canon of Rouen (appointed Bishop of Winchester by William the Conqueror). It was for-mally dedicated as the Church of the Holy Trinity on 8 April 1093. The other tranche, the long nave, which gives the Cathedral its extraordinary 164m-long stretch, was prob-ably not completed until the 1120s.

Barry Shurlock (1986) tells the anec-dotal story of Wakelin's determination to build the Cathedral. The story goes that he wished to take trees from Hampage Wood, between Winchester and Alresford. He was told that he could take as many as he could in three days. Wakelin duly sent in a team of axe men and, in the allotted time, managed to clear the wood!

The Cathedral, unlike its predecessor, the Old Minster, was designed as a single building, so that wherever the visitor stood, the full magnificence of the interior could be seen.

Today, the Cathedral offers visitors a cornucopia of historical insights.

In the Retrochoir stands the 1962 ironwork representation of St Swithun's shrine, built by Brian Thomas and Wilfred Carpenter Turner.

Swithun was born around the year 800 and, before becoming Bishop of the Cathedral in 852, he was the Prior of the Winchester Cathedral monastery. He was renowned for his learning and it is said that King Aethelwulf (795–858) set great store by Swithun's advice on religious, financial and martial matters. Swithun had many churches built and liked to oversee the building work himself, sitting nearby and watching. He was said to be a humble man and went quietly on foot to the dedication of these churches, not wishing to bring attention to himself with great display.

Swithun was known for his kindness and believed to be favoured by God; it was thought that he would perform a miracle in his own lifetime. It is for this that he is remembered. Seeing that many of the poor had to ford the River Itchen on foot as best they could, Swithun took decisive action: When they came into the city to sell their

Above: The Pilgrims' School. (By kind permission of the Dean and Chapter of Winchester Cathedral)

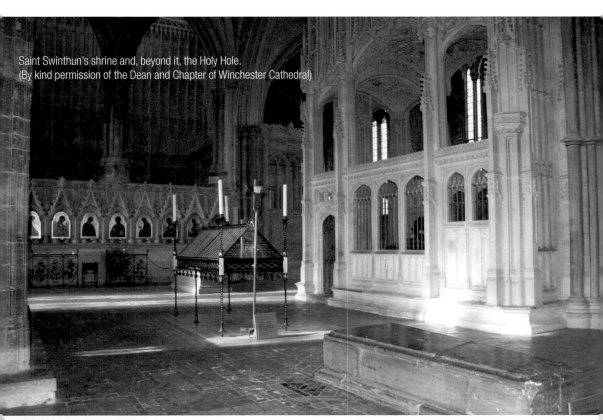

Saint Swinthun's shrine and, beyond it, the Holy Hole.
(By kind permission of the Dean and Chapter of Winchester Cathedral)

wares, he ordered that a substantial bridge, made of stone, be built at Winchester's eastern gate. As he was crossing this bridge on the momentous day, a passing monk bumped into an old peasant woman, who was taking her eggs to market. The eggs landed on the cobbles and all were smashed. The old lady was distraught, for the eggs were her only source of income. Swithun stepped forward and picked up the eggs and the woman saw that they were intact once again. This miracle was commemorated on the Thomas/Carpenter Turner shrine, set up by the Friends of the Cathedral; it has a broken eggshell on each of its four candlesticks.

Swithun died on 2 July 862 and was buried, according to his dying wishes, outside the north wall of the Old Minster. In this lowly place he stayed for a hundred years. During this time, tales of miracles performed by Swithun from beyond the grave began to circulate, and pilgrims came from ever-greater distances to visit his final resting place. Slowly, the Swithun legend grew.

On 15 July 871, Swithun's body was supposed to have been moved from its grave into a new resting place, inside the Minster. However, it started to rain heavily and this continued for the next forty days. The translation had to be halted and this date, 15 July, became St Swithun's Day.

Eventually King Edgar 'the Peaceful', grandson of Alfred the Great, succeeded in having Swithun's remains moved; they were placed in a shrine in the New Minster, inside a gold and silver reliquary, and this became the point of worship for pilgrims who travelled great distances to visit the shrine. It is said that in the ten days after his relocation there were two hundred miracles where sick people were healed. The resident monks had to give thanks every time a miracle was performed, and so the worn out holy men began to complain. According to Wendy Boase (1976), this discontent only stopped when St Swithun himself appeared and reprimanded them.

When the Normans rebuilt the Cathedral, Swithun's skeleton was placed on the new altar. By now it was headless, as Aelheah, the Bishop of Winchester, had taken the skull with him in 1005 when he went to Canterbury. A century later the skull was in Évreu, in France. In the meantime the skeleton was further plundered; an arm bone was taken to Stavanger in Norway for the Cathedral consecrated there in Swithun's name.

A new shrine to Swithun was built in 1476, but it fell victim to the Reformation less than a hundred years later in 1538, when it was demolished; the materials were recycled elsewhere. Saint Swithun's first resting place has now been established and a marble slab rests there, which marks the spot on the Cathedral green.

In the north aisle, the Tournai black marble font dates from the twelfth century. It is carved from a single piece of stone and is one of only seven such fonts in England. It depicts scenes from the life of St Nicholas, patron saint of children, on the south and western sides; the saint gives dowries to poor nobleman's daughters to stop them entering a life of prostitution, and restores murdered boys back to life. On the east side there are doves and bunches of grapes and on the north side there are roundels, more doves and a salamander. The font was used to baptize several royal children, including Henry III. It owes its place in

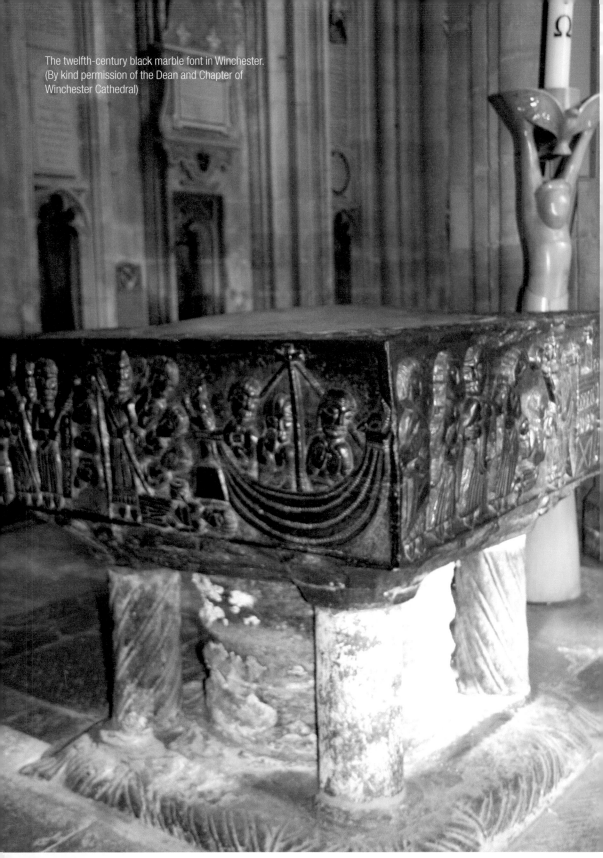

The twelfth-century black marble font in Winchester.
(By kind permission of the Dean and Chapter of
Winchester Cathedral)

the Cathedral, like so many of the features inside it, to Henry de Blois, the Bishop of Winchester (*b.* 1101, Bishop of Winchester 1129–71), who liked to beautify churches and was considered something of an eccentric in his day for doing so.

Blois was born two years after the death of Bishop Wakelin and was the son of Stephen (Count of Blois) and Adela, William the Conqueror's sister. At the age of twenty-nine, he was made Bishop of Winchester and, with the advantages of birth, education and a liberal attitude became, as Bussby (1979) puts it, 'the most powerful of English bishops'. It is due to Bishop Henry that Winchester has the Hospital of St Cross and many of the treasures inside Winchester Cathedral. The most notable of these is the Winchester Bible.

Claire Donovan (1993) points out that in a time when the average Bible is printed in a single volume, in tiny print and on almost see-through paper, a Bible which is in four volumes and has been produced with an extraordinary regard for quality is communicating 'emphatically that this is the most important text of all'.

The Bible is a product of the Winchester School, St Swithun's Priory, and is the biggest of the surviving Bibles made in England. Its 468 folios are of calfskin parchment and the text is complete; an amazing feat considering it has survived the ravages of Henry VIII's Dissolution of the Monasteries and the English Civil War. The lavishly decorated and historiated initial letters are outlined, but not all have been finished; the work is mostly that of one single scribe. One reason proffered for the incomplete decoration is that the Bible's patron, long held to be Bishop Henry de Blois, died before it was finished.

The medieval glazed tiles on the floor of the Retrochoir, the largest covering in Europe, are predominantly thirteenth century, but some, a precious few, also owe their place to Bishop Henry and his love of beauty. The tiled area is the largest and oldest to survive in England. They are red and white clay with a white clay infill to show off the pattern stamped into them. Some of the tiles have been found to pair up with those found in Winchester Castle, some form larger patterns, whilst others still have standalone geometric patterns. Christopher Norton (1993) calls them 'a monument of international significance' and what makes them all the more remarkable is that main thoroughfare pavements do not usually survive; that these have done so, and in such quantity, is outstanding. The tiles are very fragile but walking on them, if done so with care, is still possible.

The paintings in the Holy Sepulchre Chapel are mostly thirteenth century; they are dated, according to their style, to about 1220. However, in the 1960s the thirteenth-century painting on the east wall was removed (a remarkable display of technical skill) to the further end of the chapel and the paintings of the deposition and entombment of Christ, dated to about 1170–80, were revealed. They are said to be the finest Romanesque paintings in England. The paintings share the same naturalistic draperies and coloured backgrounds as the Winchester Bible, although they are the work of different hands.

Winchester Cathedral holds six mortuary chests, which rest high up on the Caen stone presbytery screens. They date either from 1525 or from 1661, when two were copied after being damaged during the Commonwealth. They hold the bones

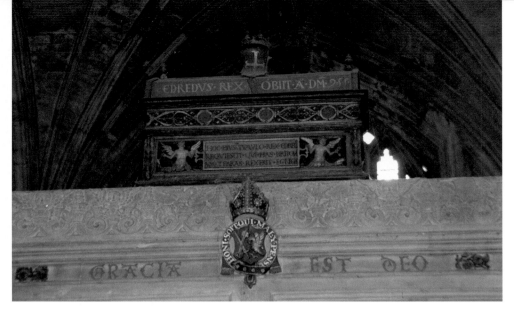

King Edred's mortuary chest. (By kind permission of the Dean and Chapter of Winchester Cathedral)

of several Saxon and Danish monarchs of Wessex, from King Cynegils (611–43) onwards, and include those of the most well-known Danish King, Canute. The bones of early Winchester bishops are also held within the chests. The chest shown in the photograph above, which dates from 1525, holds the bones of King Edred, who was crowned in Kingston–upon–Thames, aged 23, in 946. He was a son of King Edward the Elder and ascended the throne on the death of his brother, King Edmund I. He ruled for just over nine years, during which time he expelled Eric Bloodaxe, the Viking King of York. Edred suffered from ill health and had great difficulty eating. He died, unmarried, in 955 at Frome in Somerset. Originally, the bodies in the chests were buried in the Old Minster, but when that was pulled down the bodies were exhumed and interred again in the chests. They survived the Reformation and were then placed in their current positions.

Bishop Henry Beaufort (1375–1447), the great benefactor at St Cross who founded the Almshouse of Noble Poverty, was the patron of the Great Screen, the magnificent backdrop to the high altar in the Cathedral. When he died he left the means to build the screen and work began in 1455. It involved carving the saints in their myriad niches, in Caen stone; it took twenty years. The Great Screen depicts the crucified Christ surrounded by the apostles and saints. All the figures were destroyed during the Reformation and those on display now are nineteenth-century copies.

The choir's stalls date to 1308 and have misericords (ledges to support the medieval monks during long services). They are carved with animal, human and mythical figures. Between the stalls lies the unadorned tomb of William Rufus, the King who was killed while hunting in the New Forest. In 1868, William's tomb was opened; amongst the contents were the bones of a thickset man who had died in his middle age. There was also an arrow tip, and it was speculated that this could be the arrow that had killed the King in 1100.

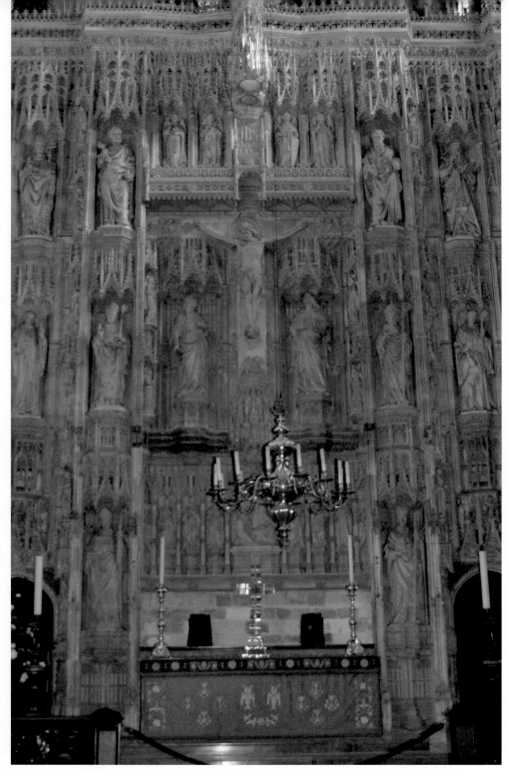

Cardinal Beaufort's Great Screen. (By kind permission of the Dean and Chapter of Winchester Cathedral)

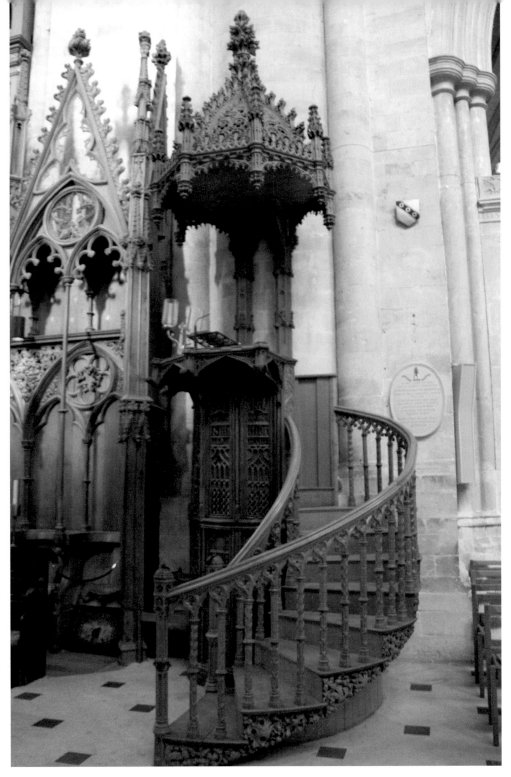

Prior Silkstede's magnificent pulpit. (By kind permission of the Dean and Chapter of Winchester Cathedral)

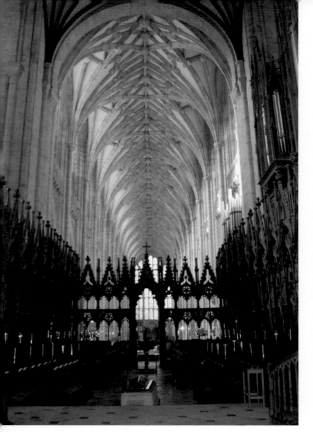

The tomb of King William Rufus sits in superb surroundings. (By kind permission of the Dean and Chapter of Winchester Cathedral)

The magnificent pulpit bears the name of Prior Silkstede (1498–1524) and is carved with skeins of silk – a medieval pun!

The Black Death, the great plague which swept across Europe killing indiscriminately as it went, reached England in 1348. It decimated half the population of Britain and many of the monasteries. As a result, frightened people started to think of their future; they began giving money freely to fund Masses for the souls of the departed and for the provision of chantries. In the 1983 edition of his work on the monuments of Winchester Cathedral, G.H. Blore helpfully explains the term 'chantry'. To begin with, he writes, it meant 'the endowment of priests who were to say Mass'. Eventually, the term came to be used in an architectural sense to mean a chapel.

The earliest chantry at Winchester Cathedral is that of Bishop William of Edington, who was Bishop between 1345 and 1366; William of Wykeham succeeded him. Both of these early chantries are in the nave. Wykeham's chantry is the grander of the two, with perpendicular detailing to the two enclosing screens; the base and the effigy are of alabaster. The colour is nineteenth century, the result of a restoration by Wykeham College members in 1894–97 and the statues in the niches are by Sir George Frampton. The attitude of the effigy is unremarkable; a pious man of substance. However, at the base stands a group of figures. These are lively little fellows who were originally believed to be chantry priests but are now thought to be secular priests who carried out his building work and who acted as his executors.

Wykeham (1324–1404) was born into a poor but respectable family. He was sent to Winchester Cathedral Priory School by the virtue of a patron, believed to be Nicholas Uvedale, Lord of the Manor of Wykeham, who was also the Governor of Winchester Castle. He later became Uvedale's secretary and was recommended to Bishop Edington, the Bishop of Winchester Cathedral. Wykeham's talent was in architecture. There is a record of Wykeham as the Clerk of all of the King's Works, in 1356, in the Manors of Henley and Easthampstead, and later that year he was the Clerk of Works at Windsor Castle, superintending the rebuilding of part of the castle. It was from this point that the King's favour and bounty flowed and, having taken holy orders, he began to rise in the Church, as well as taking up a series of royal appointments. By 1366 he declared himself 'Sir William of Wykeham, Clerk,

Archdeacon of Lincoln and Secretary of Our Lord, the illustrious King of England, and Keeper of his Privy Seal.'

In October 1366, Bishop Edington died and Wykeham succeeded him. In 1367 he was also appointed Lord High Chancellor of England. He held this post until 1371 when, as a consequence in a change of the law which stated that only the laity could hold high office, he handed back the privy seal and stood down as Lord High Chancellor of England.

Wykeham set about renovating the several residences he had inherited with his new bishopric, using much of his own money to do so. He attempted to reform abuses he found within his diocese. One such example was the problem of the Hospital of St Cross, which had been subject to the erosion of rights and fraudulent activity for many years.

Wykeham worked hard to gain his wealth and, in 1373, used it to set up Winchester College as a place of learning for poor scholars. He came against charges of bribery and corruption in 1377, but he was only found guilty of one charge – that of halving a fine he thought was too high and altering the rolls of chancery recording it. For this he was fined heftily but, after King Edward's death later that year, Richard II pardoned him and in 1378 Wykeham founded New College, Oxford.

The last years of Wykeham's life were preoccupied with politics; the turbulent times of Richard's reign began to bite. He was recalled to the post of Chancellor when the King took power in 1389 and held the post until 1391. In 1394, he began work on the recasting of the nave in the Cathedral. However, he disapproved of Richard's increasingly difficult behaviour and it is thought that he was part of the revolution that brought Henry IV to the throne in 1399. He died in September 1404, having made a will that left large bequests to family, friends and religious houses. An annual obit service (a service held on the anniversary of his death) is held on 27 September.

Cardinal Henry Beaufort is another great name in the Cathedral and his chantry, in the Retrochoir, has pinnacled canopies with vertical lines; it is magnificent, if much restored. The chantry was 'demolished' in 1642 according to G.H. Blore, when troops sacked the Cathedral. Later, in the

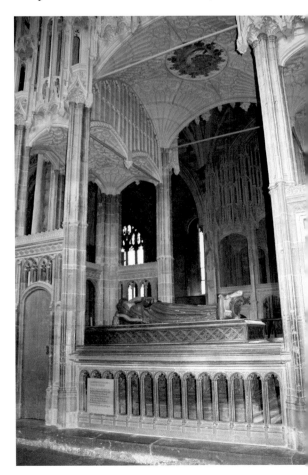

Cardinal Henry Beaufort's chantry. (By kind permission of the Dean and Chapter of Winchester Cathedral)

nineteenth century, the falls of stone from the canopies and pinnacles, said to be 'a horse-load' according to Britton writing in 1817 (cited by Vaughan, 1919), called for serious renovation. Henry Charles, Duke of Beaufort, undertook this work in 1819. The effigy dates from the Reformation and has been criticized as a 'clumsy piece of workmanship' by Britton. Beaufort was the son of John of Gaunt; King Henry IV was his brother. He was born in the chateau de Beaufort, Anjou, France, in about 1375. He was made the Bishop of Winchester in 1404, a position he held until his death in 1447; he was also made Cardinal in 1426.

Beaufort was central to the politics of the time. He held the Chancellorship of England three times under Henry IV: in 1403 for a year – a position he resigned from when he became Bishop of Winchester; in 1413, under his nephew Henry V; in 1424 under his nephew Henry VI, but this time he was forced to resign after falling foul of one of the King's other uncles, the Duke of Gloucester, with whom he frequently quarrelled.

Beaufort was present at Joan of Arc's martyrdom and on her canonization her statue was placed opposite his tomb. Beaufort is remembered for his legacy to the Cathedral, which allowed the building of the Great Screen behind the high altar. The shrine of St Swithun was relocated next to his chantry, reflecting his continuing influence, even after death. An annual obit service is held on 8 April for Beaufort.

Between the 1962 St Swithun shrine, in the Retrochoir, and the Great Screen, is the Holy Hole. This is a short passageway, resembling a small doorway from the outside. It was once much longer and would have led under the resting place of the Saint's bones on the feretory platform. Pilgrims would crawl through the passageway in order to get as near as possible to St Swithun's resting place, hoping for him to work a miracle and cleanse them of their disease.

Wakelin's Romesque crypt is open to the public and is well worth a visit. It was excavated to a depth of about 7ft and is accessible in the summer, when it is dry, but viewable from a platform when it is flooded. The crypt has an open well, under the high altar, which pre-dates the Cathedral. The huge cylindrical piers here are the earliest in the building. The Norman vaulting is evident throughout the crypt, which might possibly have been used as a procession way for monks and pilgrims to St Swithun's shrine, an alternative to walking through the Cathedral itself.

In the north aisle of the crypt stands Antony Gormley's 1986 statue 'Sound II'. It is the figure of a man with a bowed head and cupped hands, and is made of lead. Its design allows water into the cupped hands. When the crypt floods, the figure stands in the water, creating stunning reflections.

Outside, the south wall is of interest. There are the ten buttresses built between 1905 and 1912, which helped to save the building from collapse. Originally there was a Norman cloister abutting the south wall, which would have helped to steady it. There is a small plaque, which simply says, in Latin, that the buttresses propped up the Cathedral in 1912.

In the grounds outside the Cathedral, which were lowered and cleared of the tomb stones and many of the dead opposite the entrance in the 1960s, stands John Tweed's bronze memorial to the King's

Royal Rifle Corps, from 1922. The Corps was originally raised in colonial America in 1756 and saw active service during the Napoleonic war. Winchester has a history of training rifle battalions; over 11,000 of its members fell in the First World War.

Also in the grounds, with the Cathedral forming a charming backdrop to the piece, is Dame Barbara Hepworth's (1903–1975) 'Construction (Crucifixion)'. This 1966 bronze and colour statue, one of three cast, is a homage to Dutch painter Piet Mondrian

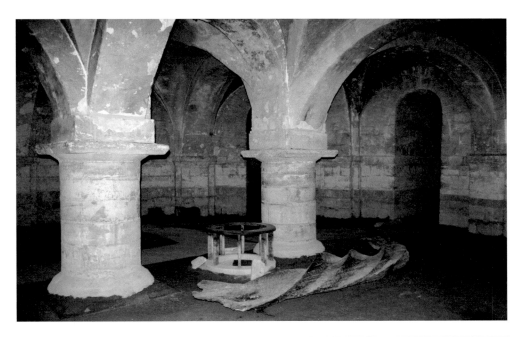

The well at Wakelin's crypt. (By kind permission of the Dean and Chapter of Winchester Cathedral)

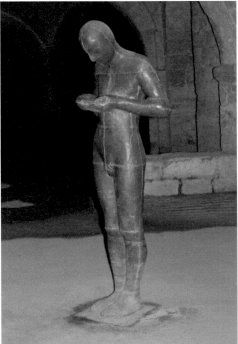

Antony Gormley's 1986 statue 'Sound II'. (By kind permission of the Dean and Chapter of Winchestr Cathedral)

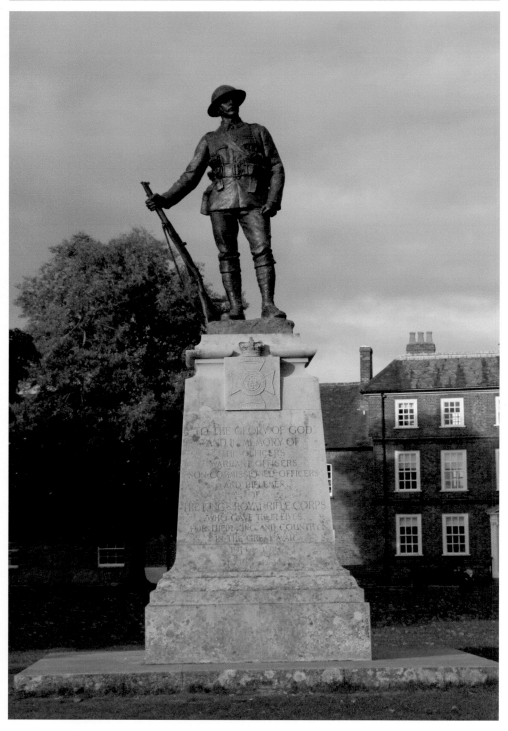

The 1922 memorial to the King's Royal Rifle Corps.

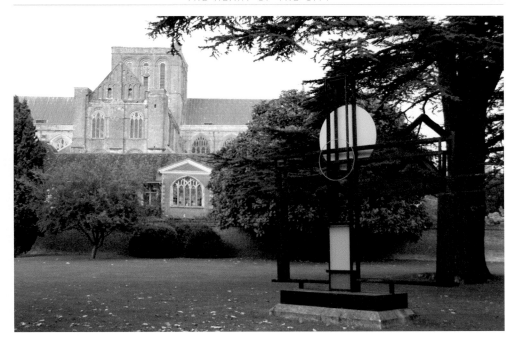

Dame Barbara Hepworth's 'Construction (Crucifixion)'.

(1872–1944), whose influence can be seen in the colour of the central disk, in the circle representing Christ's halo, and in the lines of the central cross and the crosses of the two thieves either side of it. The three colours represent pain, purity and deity.

The Pilgrims' Trail

In medieval times it was common for pilgrims to make the journey from St Swithun's shrine in Winchester Cathedral to Mont St Michel in Normandy to worship St Michael, where he is regarded as the patron saint of mariners. The popularity of worshipping St Michael led to there being over six hundred churches dedicated to the saint in England by the sixteenth century. His saint's day, Michelmas, is celebrated on 29 September.

The trail the pilgrims followed began at Winchester Cathedral and wove its way over 155 miles of Hampshire and French countryside via Portsmouth and the English Channel. Nowadays, the way is marked green in Hampshire and blue in France.

The Pilgrims' Way

This was a pilgrimage of 112 miles from Winchester to Canterbury. It follows an ancient path, far older than the medieval Christian pilgrimages, or even those of the Roman era. In fact, according to Seán Jennett (1971) the path goes back as far as Neolithic times, when people would travel to the ancient stones at Stonehenge or Avebury. Later it became part of the route to Canterbury, although, as Jennett points out, it was referred to as the 'Old

Road' up until Victorian times, rather than 'Pilgrims' Way', due to uncertainty as to whether it was, in fact, the route taken by pilgrims to Canterbury. Today it is taken to be the route and is sign-posted accordingly at points from St Swithun's shrine to Canterbury Cathedral, the site of Thomas Becket's martyrdom.

William Walker, the diver who saved Winchester Cathedral

At the time Winchester Cathedral was consecrated, it seemed perfectly stable. However, nearly a thousand years later, by the beginning of the twentieth century, it was sinking. The original construction had not been given enough buttressing and the foundations were insufficient to hold the mighty load it had been asked to carry for a millennia. Splits in the walls had been spreading for years and subsidence was evident in the crypt. In 1905 things came to a head. Cracks in the south wall of the Retrochoir, the area behind the choir, had been caused by subsidence in the east end of the Cathedral and they had become such a problem that they were impossible to ignore. The Cathedral needed major structural underpinning or it would not be long before parts of the majestic building simply collapsed.

The Cathedral's Dean, William Furneaux, wanted £20,000 to pay for the work needed and so set about pleading for it. A letter was published in *The Times* and reprinted in the *Hampshire Chronicle*, explaining the problem and the recommended remedy, and donations started to trickle in.

The main problem was water. The site of the seventh-century Saxon Old Minster,

now marked out in the turf beside the Norman replacement, stood to the north of the site of the present building. The Cathedral nave lay across the Saxon site on a good foundation of river gravel; the land gently sloped towards the River Itchen. To the east, however, the land was marshy, and the chalk and lime valley floor concealed a 3ft layer of peat atop the river gravel. The Cathedral foundations stopped before the peat level and, after the marl and some of the peat had been removed, the Norman builders poured flint and chalk in and, in some cases, short oak trunks were dug down, sometimes reaching the gravel. On this foundation, the Cathedral was built; the peat compressed and held the mighty weight for centuries. However, eventually over time the foundation began to give way, hence the severe subsidence that came to a head at the beginning of the twentieth century.

Thomas Jackson, the Winchester Diocese architect, suggested bonding and grouting the walls and then underpinning them to the gravel bed, 16ft below ground level. The expert on underwater foundations was consulting engineer Francis Fox (1844–1927), who was knighted for his work on the Cathedral in 1912. His experience was invaluable, as he had already helped to build Marylebone railway station and the London Underground. He had the idea of sending a diver into the water to lay concrete directly on the gravel. Two divers were signed up to do the work; the lead diver, William Walker (1869–1918), was the most experienced of the divers. They were from Siebe Gorman Limited, a company that had developed the water-tight, closed diving helmet.

William Walker was trained as a diver in Portsmouth dockyard. In 1892, after five

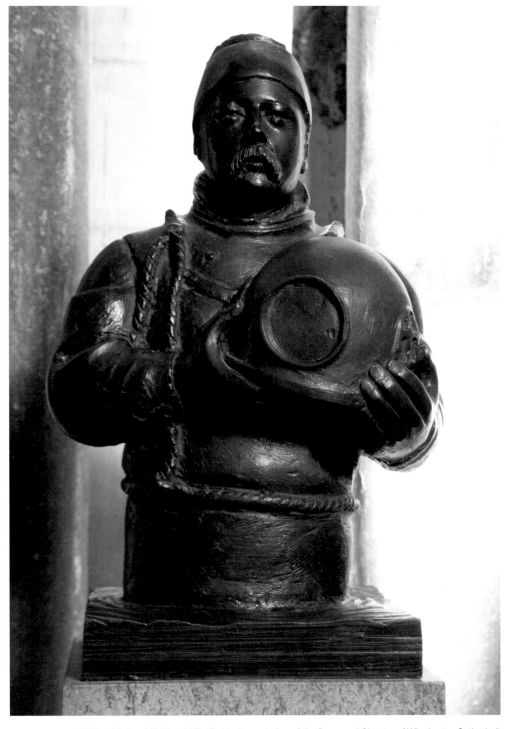

William Walker (1869–1918). (By kind permission of the Dean and Chapter of Winchester Cathedral)

years of training, he became a deep-water 'First-Class Diver'. He went on to work on the construction of the Blackwall tunnel, the shipyard in Gibraltar, and on rescue and emergency work in Wales. He was also involved in experimental work with the Admiralty in order to learn more about underwater pressure.

In rescuing Winchester Cathedral, Walker worked in water 18ft deep, as he systematically laid concrete into each of 235 4ft-wide pits, which were dug around the south and east subsiding walls. For six hours a day, five days a week, between 6 April 1906 and 8 September 1911, Walker toiled in a diving suit weighing 200lbs. At weekends he would return to Croydon to see his family, sometimes even cycling there; a tremendous endurance feat.

Walker worked in complete darkness; as the water was full of sediment no light would penetrate. He removed the peat, levelled the gravel and laid bags of concrete. When the concrete had set, the water could be drained off and blocks of concrete and bricks were laid. In total, 25,800 bags of concrete, 115,000 blocks of concrete and 900,000 bricks were needed to complete the work. The cost of the job escalated to £113,000, which meant that repeated appeals for funds had to be made. King Edward VII himself contributed £250, but, as Ian T. Henderson points out in his book *The Winchester Diver, The Saving of a Great Cathedral*, finding funds in an age when industry did not contribute, and supporting charities were a thing of the future, was 'a desperate business'.

A service of Thanksgiving took place in the Cathedral, presided over by the Archbishop of Canterbury, on 15 July 1912, at the end of the work; King George V and

Queen Mary attended. They made it their business to stop and speak to those involved in the preservation work. For William Walker this was particularly poignant, as he had given the King diving lessons years before when he was a naval cadet.

William Walker was married twice and was a member of the Royal Victorian Order (MVO). He was a modest, robust man who loved his pipe. At the age of fifty-four he succumbed to the Spanish influenza epidemic that swept through the country in 1918. Each year he is remembered in prayers said for him at the Festival Evensong of the Friends of Winchester Cathedral and, as Frederick Bussby (1970) points out, he is the workman who has become a legend, with a statue across from that of Joan of Arc. The statues around him, of those who were also involved with the rescue of the Cathedral, have largely been forgotten.

The Hampshire War Memorial

In the First World War, 20,000 soldiers from Hampshire and the Isle of Wight were killed. The Hampshire War Memorial, set opposite the west door of Winchester Cathedral, was unveiled in October 1921 by the Lord Lieutenant of Hampshire, John Edward Bernard Seely, 1st Baron Mottistone (1868–1947). The architect was Herbert Baker (1862–1946), who was also responsible for much building work in South Africa and the building of New Delhi in India.

It had, at first, been thought that the memorial would be to those killed from the Hampshire Regiment, but the net was widened to include all those who fell from the county and from the Isle of Wight.

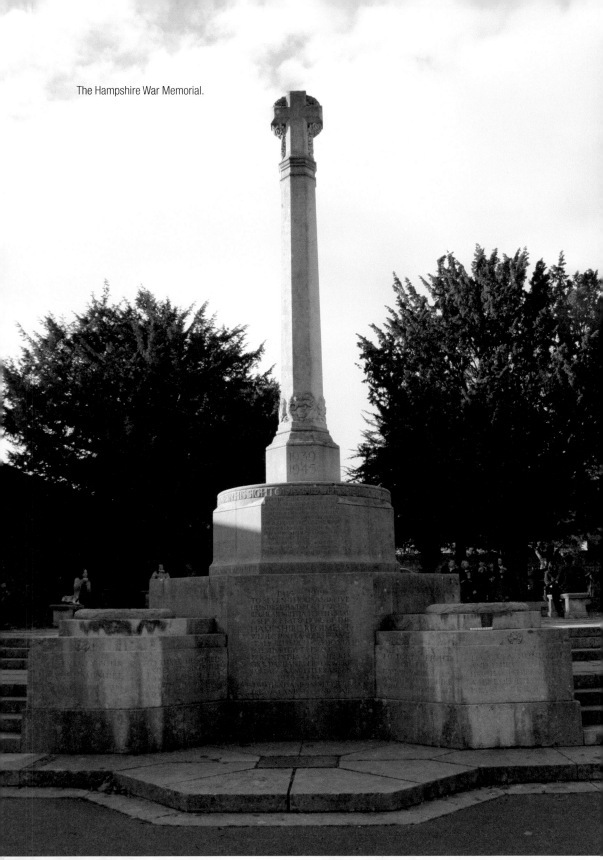

The Hampshire War Memorial.

At the base of the cross, a stone from Ypres was incorporated as a reminder of the worst of battles during the conflict.

Morley College

The name Morley crops up more than once in Winchester's history. George Morley (1597–1681) was born in Cheapside. He was a canon of Christ Church, Oxford and stood by King Charles I, which led to a brief imprisonment in 1648. In 1649, it was Morley who supported Charles as he was led to the scaffold. After the King's execution, he went abroad and lived with Royalist exiles in Belgium and in Holland until the Restoration.

Morley was consecrated Bishop of Winchester in 1660 and in 1672, Bishop Morley founded a charitable establishment for the widows of clergy in the city and Winchester Dioceses. The current building, standing on the original site by the Cathedral Close in Market Lane, bears the plaque taken from the original building over its front entrance. This is adorned with the Bishop's mitre.

The first building was replaced in 1879–80 and the site was enlarged to include the area occupied by the city pillory and the cage. According to Keene and Rumble (1985), the cage 'for the confinement of petty offenders' had been moved to the area now known as Market Lane in 1529. When it was moved, a new pillory had been built to complement it. In 1721, when this area was split into two parcels, the cage was still there, sitting on the southern section. By 1737 a stable

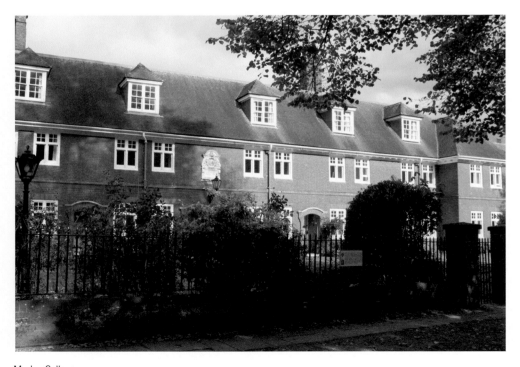

Morley College.

and dung pen were on the northern section and a house was built on this site later. In 1843 the Dean and Chapter of Winchester Cathedral bought both parcels of land in order to expand Morley's College. Today the property is under private ownership.

The City Museum and 'Luminous Motion'

The City Museum, standing in the Square, a stone's throw from the Cathedral, was purpose-built in 1903. It stands on the site of the old Market Hall, which had a theatre upstairs. Later, it was the site of the Mechanics Institute and Reading Room. In front of the building the old pillory used to stand.

Just to the side of the flint-fronted building is Peter Freeman's 6m high 'Luminous Motion'. This dates from 2002 and is essentially a column of lights, which are interactive. It was created for part of the Winchester Light Art Project. The fibre-optic lights, encased in stainless steel, change colour when members of the public send in text messages to the number on the base. The artist was influenced by the medieval Axis Mundi, the idea that there was a pivot at the centre of the earth around which all of creation flowed; he believed that Winchester was sitting on the meeting point of spiritual and political pathways. 'Luminous Motion' looks to the future of a new technological pathway for Winchester; it was funded by the National Lottery, through the Arts Council of England.

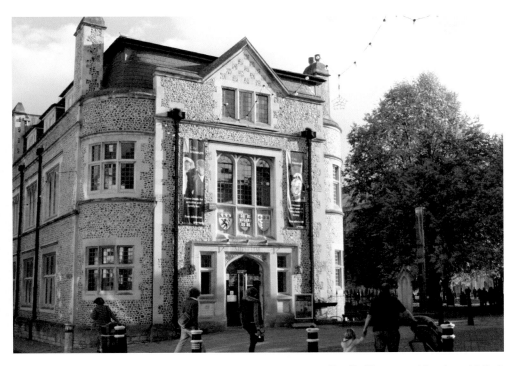

The City Museum and 'Luminous Motion'.

The Church of St Lawrence in the Square

It is easy to miss this tiny church; it is literally squashed between the shops in the High Street and the Square. The entrance is nondescript and opens out into the narrow passageway between the two busy areas. Taking the time to seek it out and pop inside is worth the effort.

It is thought to be of Norman origin and the north wall may be part of the royal palace built in the area in 1069–70. The tower is fifteenth century. During the Commonwealth the church was used as a school and the building was restored during this time. It has been the subject of much restoration since then.

Inside, the open interior measures just 32ft in width. There is a feeling of space though, due to the beamed ceiling dating from about 1662–72. The panelling on the south wall is neo-Jacobean. The stained-glass window above the panelling shows four bishops of Winchester and dates from 1898. It was made by the Whitefriars Glassworks, owned by James Powell & Sons and was donated in memory of the rector, Henry Manning Richards (in office between 1871 and 1894). The bishops are St Swithun (800–862); William of Wykeham (1324–1404); William of Waynflete (1395–1486), holding the chapel he founded at Magdalen College, Oxford; Lancelot Andrewes (1555–1626), scholar, writer and preacher. The coats of arms are all personal to the rector; Eton College, his school; Christ Church College, Oxford, his university and the Diocese he worked in, Winchester.

St Lawrence (c. 225–258) is depicted in the engraving in the window by the vestry door, in the middle of the south wall. The image shows him in the robes of a deacon and holding the gridiron upon which he was martyred.

There is an interesting list of benefactors preserved high up on the west wall. These were parishioners of standing, who wished to help those in need in the parish. Amongst them are Mrs Anne Neal, who gave 'forty shillings for ever to be given to nineteen poor women' and Joseph Percival, who, in 1715, gave £10 for the 'reading of prayers' in St Lawrence's Church.

The royal coat of arms was donated to St Lawrence's Church from St Maurice Church. The original from St Lawrence's was lost in a fire in 1978. Saint Maurice's Church was demolished in 1957; only its tower was left intact, which still stands in Market Lane. The City Council gave the preserved coat of arms from the old church to St Lawrence's in 1980. It is remarkable because it is marked G III R, but the design is more modern than George III (1738–1820) and is, in fact, that of Queen Victoria, created in 1837. The 'V' for Victoria is over-painted on part of the King George marking. The last restoration was due to the 1978 fire and was completed by Richard Sawyer in 1979–80.

The Eclipse Inn, Winchester

For many years the building sandwiched between two much later edifices was the rectory of St Lawrence's Church. Today it is a public house and has been since 1890. It is famous for being haunted and for the none-too-pretty events which happened there in the seventeenth century.

'Hanging Judge' George Jeffrys was born in Wrexham in 1648. As Lord Chief

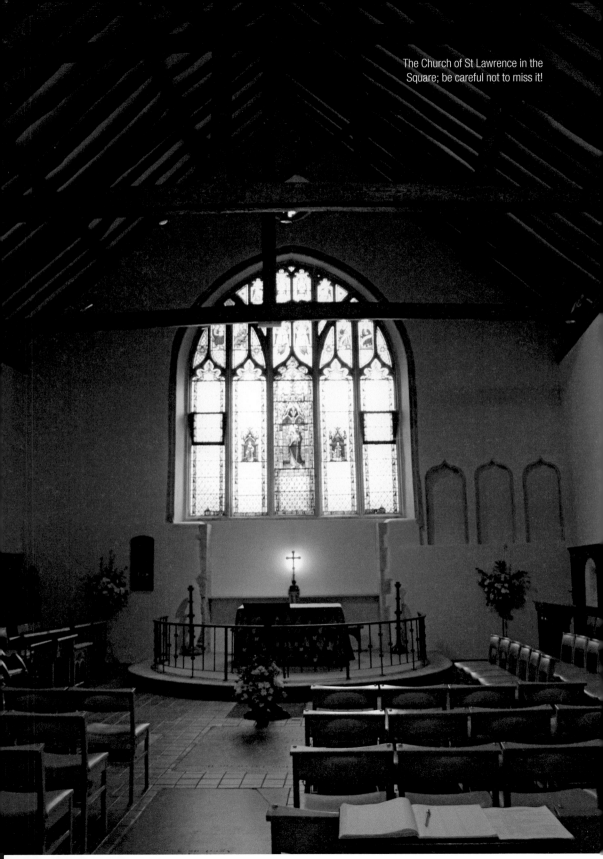

The Church of St Lawrence in the Square; be careful not to miss it!

Justice, he was the leader of the judges at the 'Bloody Assizes', the trials that took place following the collapse of the Monmouth Rebellion, at the Battle of Sedgemore in 1685.

The first trial took place in Winchester on 27 August. Dame Alicia (also known as Lady Alice) Lisle, a respected and gently born lady of over seventy years of age, was accused of treason. Alicia had married a lawyer, John Lisle, son of Sir William Lisle of Wootton on the Isle of Wight, when she was nineteen. The couple settled in Winchester, where he became one of the two members of Parliament and the recorder of the city. John sided with the Parliamentarians in the Civil War and was a judge at the trial of King Charles I. He was one of those who signed his death warrant in 1649.

The couple prospered; John Lisle was made the Master of the Hospital of St Cross and Alicia inherited Moyles Court, Ellingham, near Ringwood. They also held property in London and in Chilbolton, but this prosperity brought enemies.

The restoration of the monarchy was a disaster for the couple and by this time they were parents of a large family. In 1660 John was excluded from the pardon given under the Act of Indemnity and Oblivion. He knew he was in trouble and escaped to Switzerland, leaving Alicia at home with their children. In 1664 English agents assassinated him in Lausanne and all except Alicia's personal property, Moyles Court, was seized.

Alicia was left with little money to provide for her family. Moreover, she resented the fact that the Wootton estate had not been given to her son, whom she felt was the rightful heir. She quarrelled with her brother-in-law, William Lisle, a Royalist, who had been granted the estate. Furthermore, her husband's money was given to James II, then the Duke of York. The provenance of the money was difficult to obtain and this brought unwanted attention to Alicia, which was not forgotten later.

After the Monmouth rebellion, she had taken two fugitives into her home at Moyles Court; John Hickes, a person known to her as a minister in Portsmouth, who had sent a message asking for sanctuary, and a man he brought with him and whom she had never met before, Richard Nelthorpe, a wanted outlaw. Spies had immediately passed on the news of the arrivals and it was not long before the authorities were involved. Dame Alicia said at her arrest, and at her subsequent trial, that she had supposed that Hickes was wanted for poaching or for something connected to his ministry.

According to 'Alice Lisle's Article' in the *British Dictionary of National Biography* (1997), John Lisle had sentenced a Royalist, John Penruddock, to death. His son, Colonel Penruddock, was King James II's arresting officer in the subsequent treason case against Dame Alicia. He was not likely to forget what the Lisle patriarch had done, and so the events at Moyles Court on 26 July 1685 were a perfect opportunity for revenge.

At the trial, no evidence of either Hickes' or Nelthorpe's offences were admitted and the one witness, the messenger called Dunne, stood fast, despite Judge Jeffreys' best efforts to harangue him into changing his evidence. By all accounts, Dame Alicia withstood a tirade of abuse from the notorious judge. Nothing

The Eclipse Inn, where Dame Alice Lisle spent her last night.

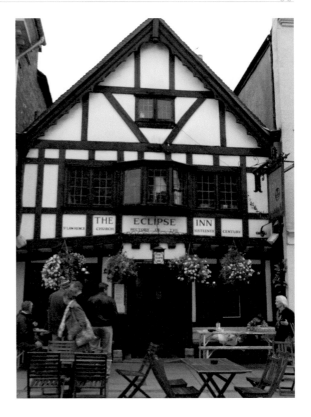

connected Dame Alicia with Monmouth sympathies, but the jury was directed to find her guilty and, terrified by the judge, it dutifully did so. Dame Alicia's sentence was to be dragged through the streets on a hurdle and then burned at the stake that same afternoon; this horrified the court. Alicia was respected and was well loved in the area. Local townspeople refused to carry out the sentence and there was rioting in the streets; the execution was delayed for five days. James II, when he was petitioned for leniency, refused to quash the decision but decreed that she should be beheaded instead of being burnt at the stake. She spent her last night at the Eclipse Inn, just along from Winchester Cathedral.

The inn, dating from about 1540, has a varied history; as a private house, a rectory,

an alehouse and an inn. The night before the execution, wooden scaffolding was erected outside the building and Dame Alicia went to her grisly end the next morning; she was buried in Ellingham churchyard. Her cortege and many of the Winchester townsfolk were in silent protest at the execution, which was widely believed to be unlawful. A later Act of Parliament proclaimed the verdict was invalid as Judge Jeffreys had not conducted the trial fairly, but this was too late for Alicia.

Since that time, the figure of Dame Alicia has regularly been seen, either in the upper bedroom she occupied at the Eclipse Inn or in the corridor just outside. Dressed in a long grey gown, she stands motionless in a corner recess.

THE COLLEGE, WOLVESEY CASTLE, CHESIL AND THE SOKE

Fire Plaques

AS THE visitor wanders around the city, the sights to be appreciated high above eye level are often missed. This is a mistake; history can be found from all directions in Winchester. Dotted around the city are the famous Sun fire plaques, securely attached to walls at about first-floor level. They were used to show that the owner of the building had taken out fire insurance and many survive on houses all over the city. The example in College Street is well preserved. Rowland G.M. Baker, of the Molesey Historical Society, has looked at fire plaques in depth and his report, available on the society's website, makes interesting reading.

In days gone by, the only recourse for those who had everything they owned destroyed by fire was to seek the charity of others via a brief (a letter issued by a court), which was distributed about the country and read out at gatherings, such as in church, in the hope that some form of charitable giving would be the result. Briefs were abolished in 1829.

There had been mutterings about the need for insurance to cover fire damage for many years, but nothing came of it until the Great Fire of London in 1666, which focused minds on the devastation that such an event could bring and the suffering it left behind. Doctor Nicholas Barbon, or Barebone, the son of the well-known puritan Praisegod Barebone, is credited with being the father of the modern insurance scheme, as we know it today. In 1681 he went into business with his partners; they offered fire insurance from the Fire Office in Threadneedle Street, in London. Insurance was provided for buildings, protecting them if they were 'Burnt down, Demolished, or otherwise damnified by reason of fire' (Blackstock, 1910). In 1705 the Fire Office was renamed the Phoenix, reflecting the emblem of the company, a phoenix rising from the ashes. The Phoenix went out of business in 1712, by which time other insurance companies had come into being in London. In 1719 the Sun Insurance Company, established in 1710, announced it would cover property all over the country.

Fire fighting was very rudimentary. Basically, if a fire started, the traditional method of dealing with it was to throw

buckets of water at it from the local pond or well. This was usually useless and so fire-breaks were created by knocking down nearby properties so that the fire could not spread. This needed the consent of a magistrate and there was usually no compensation for the luckless owner of the demolished property. The Sun Fire Office announced that its 'thirty lusty able-body'd firemen' in blue liveries with sun emblems on their arms were available to assist, aided by twenty porters. Between them they would help to put out fires and move valuables. Eventually, three insurance companies collaborated: the Royal Exchange (established in 1720), the Sun and the Phoenix (established in 1782). They joined together to pay for night watches in London and these, in time, eventually morphed into the Metropolitan Fire Brigade in 1865.

To enable identification of insured premises, lead fire plaques were issued and affixed to the first-floor front wall, as lead could survive a fire. They were needed to prove that the house had in fact been insured; the policy number was displayed underneath the fire company's emblem.

The fire plaque pictured is on a building in College Street; it is the emblem of the Sun Insurance Company. This organisation was originally based on an idea operating in 1699, pioneered by the Charitable Corporation, which gave a form of insurance for contents, rather than the building itself, and which had a warehouse to store the rescued contents until they could be re-housed elsewhere. Charles Povey incorporated this idea into his new insurance company, the Company of London Insurers, in 1708, and chose the sun emblem for his fire plaque. In 1710 the company became the Sun. It is still trading as the RSA, the Royal and Sun Alliance.

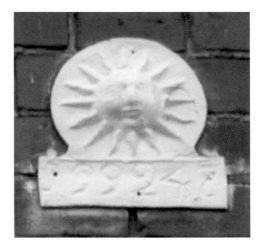

The Sun fire plaque in College Street.

Jane Austen

Winchester's claim to Jane Austen is sadly based on the fact that it was here that she came to die; she was still at the height of her literary powers. The inscription on Jane Austen's grave, discreetly lit in the north aisle of Winchester Cathedral, was written by her family and does not mention her literary achievements. However, a later plaque, placed there by her biographer James Austen-Leigh some fifty years later, seeks to rectify the omission by stating that she 'was known to many by her writings'.

In memory of JANE AUSTEN.

Youngest daughter of the late reverend GEORGE AUSTEN formerly rector of Steventon in this county.

She departed this life on the 18th July 1817, aged 44, after a long illness supported with the patience and the hopes of a Christian.

The benevolence of her heart, the sweetness of her composure, the extraordinary endowments of her mind, obtained the regard of all who knew her, and the warmest love of her intimate connections. Their grief is in proportion to their affection. They know their loss to be irreparable, but in their deepest affliction they are comforted by a firm though humble hope that her charity, devotion, faith and purity have rendered her soul acceptable in the sight of her REDEEMER.

Jane was born in the village of Steventon, the seventh of eight children to the Reverend George Austen (1731–1805), a classical scholar and tutor nicknamed 'the handsome proctor' at Oxford University (Cecil, 1978); his wife was Cassandra (1739–1827). Thomas Knight, George's patron, and his wife, adopted Jane's brother Edward, who went on to inherit two estates and much wealth from his adopted family, but remained on close terms with his biological parents and siblings.

Jane, known as 'Little Jenny' in girlhood, grew up in a happy, financially secure home. The children were all well read and several wrote verse and skits; indeed amateur dramatics were a significant part of family life in the Austen family home.

Jane and her sister Cassandra were sent to Oxford in 1783, to be educated. They both caught typhus fever when they later moved to Southampton and, after this, the girls spent a year at the Abbey School in Reading before returning home, this time for good. Jane completed the rest of her education by reading the books in her father's library.

Jane's first works were written between the ages of eleven and eighteen and she later copied a selection into three volumes to amuse her family, showing promise of the comic insight she was to bring to her later works.

In 1795, Jane began work on *Elinor and Marianne*, later to be titled *Sense and Sensibility*. In 1796, Jane started what was to become known as *Pride and Prejudice*. In 1797, Mrs Austen took her daughters to Bath (Cassandra was trying to get over the death of her fiancé, who died in the West Indies) and Jane met a young man, Sydney Smith, a clergyman employed as a tutor to Austen family friends. He was witty and amusing and may have been the model for Henry Tilney, the young man in Jane's next novel, *Northanger Abbey*.

George Austen retired in 1800 and the family moved to Bath. Jane disliked the town and missed Steventon. Later, in 1802, she refused a marriage proposal from Harris Big-Wither; he was a friend of the family and the heir to large estates nearby.

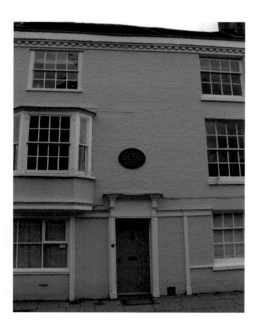

The house in which Jane Austen died; the sad event is commemorated by a memorial plaque.

In January 1805, Reverend Austen died suddenly and with him went the financial security surrounding the female members of the family. In 1806 Mrs Austen, Cassandra and Jane moved to Southampton to live with Jane's brother Frank Austen and his wife.

In 1809, Edward offered them the cottage at Chawton, which has become so well known today in relation to Jane. It was from here that four of her novels were published, all anonymously. The sales of *Sense and Sensibility* in 1811 lessened her financial worries. *Pride and Prejudice* was published in 1813 and almost immediately went into a second edition. *Mansfield Park* (1814) earned Jane more than either of the other two books and *Emma* (1815) was the last book published in Jane's lifetime.

Jane became ill, but it was not clear what the problem was; Addison's Disease, Hodgkin's Lymphoma and Bovine Tuberculosis have all been put forward as possible illnesses. At first she ignored the decline of her health, but soon had to acknowledge that she was becoming weak. She continued to write but was bedridden by 1817. Her brother Henry moved her, with Cassandra, to Winchester for medical treatment and she was placed under the care of Dr Giles King Lyford. She was moved into lodgings at 8 College Street, now owned by Winchester College; here she was attended by Dr Lyford and nursed by her sister. During this time her good humour is said to have stayed with her; she wrote an amusing poem *Venta*, about the fashionable people assembling in the town for the start of the racing season, just days before the end.

Jane made her own funeral arrangements and died at 5.30 p.m. on 18 July 1817, in the little house just along the road from Winchester College, just up from P & G Booksellers. Today the house bears a forlorn little plaque that tells of the building's sad claim to fame.

Two further books, *Persuasion* and *Northanger Abbey*, were published posthumously in 1817; they included a note identifying the author for the first time.

The College

Bishop of Winchester, William of Wykeham, founded Winchester College in 1382. It was originally named St Mary's College and it was dedicated to the Virgin Mary, whose statue, dated to about 1400, stands in the archway above the Outer Gate to the college. This statue is remarkably well preserved, perhaps because it was painted regularly. Nowadays, it is a bare and beautiful figure, benignly welcoming visitors to the school.

The Outer Gate played a part in the riots at the college in 1793 and 1818. The boys were not allowed out of the school and consequently the streets nearby were out of bounds. In 1793 one of the prefects slipped out and went along to the Cathedral Close to hear the band of the Bucks Militia play. When the boy's act of disobedience was discovered, the warden, George Huntingford, decided to punish the whole school by depriving all the children of their Easter holiday; the result was instant uproar. The senior boys took over the school, obtained the porter's keys and locked up the warden and two others. The boys closed the gates and barricaded themselves inside the school to protest. They hoisted the Red Cap of Liberty from the French revolution over the Outer

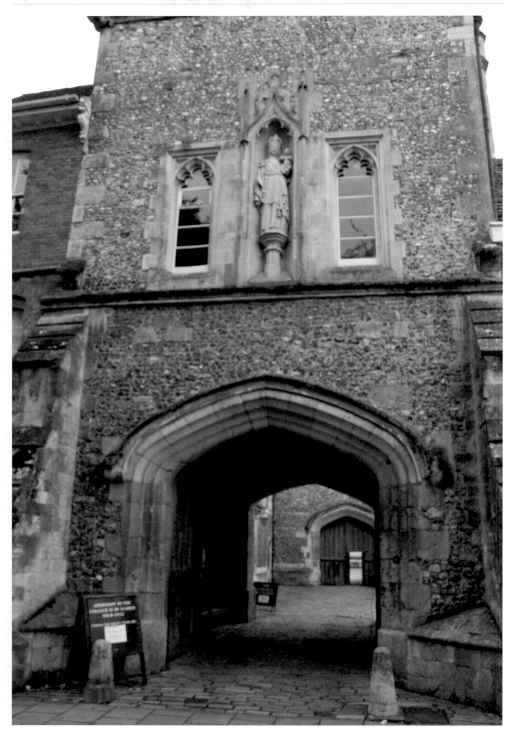

The Outer Gate of Winchester College, with the original statue of the Virgin Mary above.

Gate (making reference to the upheaval in France), and prepared for a siege. The warden, however, managed to get a message through to the Sheriff of Hampshire, who arrived with assistance to save the day. The Riot Act was read and the uprising quelled; those who had been the ringleaders were expelled.

In 1818, again under Warden Huntingford, there was another riot. This time the homesick boys, fed up with the harsh conditions within the school, were tricked by the headmaster at the time, Dr Gabell, into believing they could go home. When they attempted to do so the army was awaiting them; he was never forgiven.

The boys who came to the college had everything they needed laid on for them. From College Street it is possible to see the school brewery, the grey wall of which abuts the road to the right of the Porter's Lodge at the entrance. From the street, the curiously shaped protrusion on the roof is clearly visible. This is the cover for the hole set into the brewery roof, which was opened on brewing days to let out the smoke from the open fire within. Inside the college, in the courtyard just beyond the school gates, the old brewery (now a library) stands beside a 250-year-old, July-flowering magnolia tree. The cover over the smoke hole is also visible from this side.

This courtyard, known as Outer Court, houses the buildings used as the stables, the laundry, a granary and the slaughterhouse; the warden's residence is here today. The warden, the head of the governing body called 'The Warden and Fellows', is currently Sir David Clementi (b. 1949). When the warden is in residence, William of Wykeham's flag flies from the mast above the Outer Gate.

At the far end of Outer Court is a tower with an arched oak doorway cut into it, known as the Middle Gate. This bears a circular hole, which was used to pass scrolls through it. The letterbox just along from this is a much later addition. Above the gate are three statues: the angel Gabriel, the Virgin Mary and William of Wykeham, who is kneeling to the other two. All are original except the Gabriel statue, which was presented to the college by the parents of one of the students nine years ago; the original is kept safely in storage.

Winchester College was set up in order to train seventy poor boys for the Church. The scholars would then go on to complete their education at New College, Oxford, which William of Wykeham also founded. The original scholars were trained in letters and grammar.

The *Ad Portas* ceremony (Latin for 'at the gates') is probably what is most well known about the college; this is the welcoming speech, in Latin, to honour distinguished Old Wykehamists. The tradition grew out of the speeches of welcome that were made to examiners from New College, when they came to Winchester on their annual visit to elect scholars for their sister foundation in Oxford. The college website tells us of Mrs Letitia Williams, whose brother was first on the roll in 1605; in 1615 the tradition of paying 13*s* 4*d* to the scholar who delivered the speech was begun. The *Ad Portas* welcome is generally for Old Wykehamists, whilst the *Orato* has been delivered to royalty and high-ranking clergy. The welcome to the New College examiners stopped in 1873 but *Ad Portas* was revised in 1881, when it became the highest honour that the college bestows.

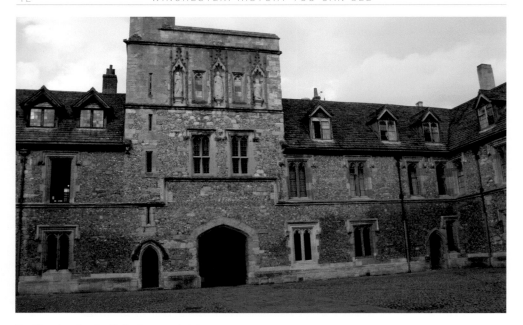

The Chamber Court, with the tower and statues.

The *Aulae Prae* (Prefect of Hall), the name for the head boy or senior scholar, delivers the *Orato Ad Portas*, and, if possible, the recipient gives a Latin reply. Wendy Boase (1976) tells of the *Ad Portas* welcome given to Professor Arnold Toynbee in 1974, who entered the college as a boy in 1902, and who replied not just in Latin, but also in Greek. Indeed, the college website tells us that of the forty-nine *Ad Portas* receptions since 1873, there were eighteen responses in Latin, twenty in English, one in the Indic language of Marathi, ten in English and Latin and Professor Toynbee's response in Latin and Greek. The *Ad Portas* ceremony takes place in the Chamber Court and everyone in the college community attends.

The Chamber Court is the original courtyard around which the first seventy scholars lived, together with the warden, ten fellows, two masters, three chaplains, three lay clerks and sixteen choristers, all

of whom William stipulated in the original foundation. They lived in chambers around the central courtyard. Today's seventy scholars, who have a scholarship to study at Winchester, still live there; all but one of the Masters now live outside of the college and the warden's residence in the Outer Court is only occupied when there are particular functions to attend at college. The scholars are distinguished by their long black gowns, which they wear to school. The college today caters for 700 students; the majority, known as Commoners, pay about £30,000 a year to study at Winchester College. Forty are day pupils and the rest live in one of ten houses on the college site, which mostly date from the Victorian era.

The three statues over the Middle Gate are repeated on the chamber-court side. It used to be the tradition, in the days when the students wore straw hats, for the boys

crossing the court to doff their hats to the Virgin Mary as they crossed.

The chapel, on the south side of the court quadrangle, dates from between 1387 and 1395 and was designed by William Wynford. It is made from Bere stone and looks high in quality in comparison to the rest of the buildings here, which are made from flint-faced bonded rubble. The traceried ceiling and the lierne vault were built by Hugh Herland and are remarkable; the vault is one of the earliest examples of this design. The individual timbers used to make up the ceiling are clearly visible and the ceiling was repainted in 1952 to William's original colours. The windows are by Thomas of Oxford, who also produced the glass in the chapel at New College in Oxford. The east window represents the stem of Jesse, the father of King David and the generations between him and Christ. The window is known as the Jesse window and he is the central character, reclining in kingly purple at the bottom of the stained glass. The glazier added tiny portraits of himself, William Wynford, Hugh Herland and the Clerk of Works, Simon Membury. Sadly, the window we now gaze upon is not the original, as this was taken down for renovation in the nineteenth century and was copied, rather than restored. It was repositioned in 1822 to acclaim at the time. The other windows in the chapel suffered the same fate. Some of the original glass has been traced and returned to the college, but it is generally agreed that the workmanship in the current windows is not as good as the original. Luckily, the recovered glass can be seen in the west window, which shows just how skilful Thomas' work was.

The reredos is fairly recent. It depicts Christ on the cross with a mother and a First World War soldier either side of him. The panelling behind the stalls depict the shields of former wardens and headmasters of Winchester College; their mitres above some of the shields denote their status as bishops. The panelling and the pews date from 1913–21.

Also on display are the Rose Tapestries. These were stitched for Henry Tudor, King Henry VII, to commemorate the christening of his son, Prince Arthur, at the Cathedral. The white rose is that of the house of York, to which Henry's wife Elizabeth of York belonged, and the red is that of Henry's family, of Lancaster. The combination is known as the Tudor Rose. The alliance between Henry and Elizabeth ended the Wars of the Roses. Their son, Arthur, married Catherine of Aragon but he died young and his younger brother, Henry VIII, was obliged to step into his shoes; the rest has become a chapter in English history.

In the passageway between the chapel and the original schoolroom is a curious set of wooden frameworks; one is dated 1819. These look like inverted ladders with upright supporting stands at either end. Currently they are used as convenient storage for bags or books, but originally their function was to hold top hats, the brim of the hat holding it suspended upside down in the opening. Of course, these stands were necessary as hats could not be worn in the chapel.

School is an impressive building, designed in the style of Sir Christopher Wren and built by Warden Nicholas in 1687. William of Wykeham's statue stands watch over the entrance doors; it was the work of C.G. Cibber in 1692, whose portrait is inside the building over the fireplace.

The west window, containing the original stained glass lost in the nineteenth century.

The frames to hold top hats worn by the boys at Winchester College in days gone by.

Either side of William are the tapestries that were made for Mary Tudor's wedding to Philip of Spain in Winchester Cathedral, in 1554. Portraits abound in this room, many of them of headmasters from the college, some of whom went on to become bishops. The names of those who helped to build the school are also to be found here. At one end of the room, the school rules, written in Latin, urge the boys to work hard and be obedient and warn that they risk being thrown out of the college if they disobey. At the other end, they are again urged to study hard, or risk being beaten with the rod; this is handily illustrated to reinforce the message! The school is no longer used for lessons, although it is a quiet place where

preparatory work can be done. Nowadays, the striking room is much in demand to hire as a meeting venue or for wedding receptions.

Outside, in the extensive grounds, is Meads. From here it is possible to get an idea of just what William of Wykeham left his poor scholars. The grounds stretch across water meadows towards St Catherine's hill in the distance; William had hop fields and a farm. Today, two-hundred-year-old London plane trees dominate the scene and become particularly picturesque during autumn months when the rust-coloured leaves spread a carpet over the green. Standing on the side of the playing field is Bethesda House, the old sick room and now the home of the college matron; the science and music facilities; the Commoners' houses and the heart of the modern college, including the shops.

The wall encircling Meads, largely made of recycled stone from what was St Elizabeth's College (destroyed in the Reformation), is the scene for 'Ilumina', the event which takes place on the last night of the Christmas term. On this occasion a bonfire is lit and the boys place candles in the tiny niches (called temples) in the surrounding walls; the choir then sings carols to the assembled company.

At the mill, novelist Anthony Trollope's (1815–1882) initials are carved into the mill's stone. Close by, next to the swiftly flowing River Itchen, is the small gate that was reserved for those boys who were expelled. It only opens one way, so that once outside the expellee could not return.

The pillars in the cloisters have become endearingly wonky with age. They were

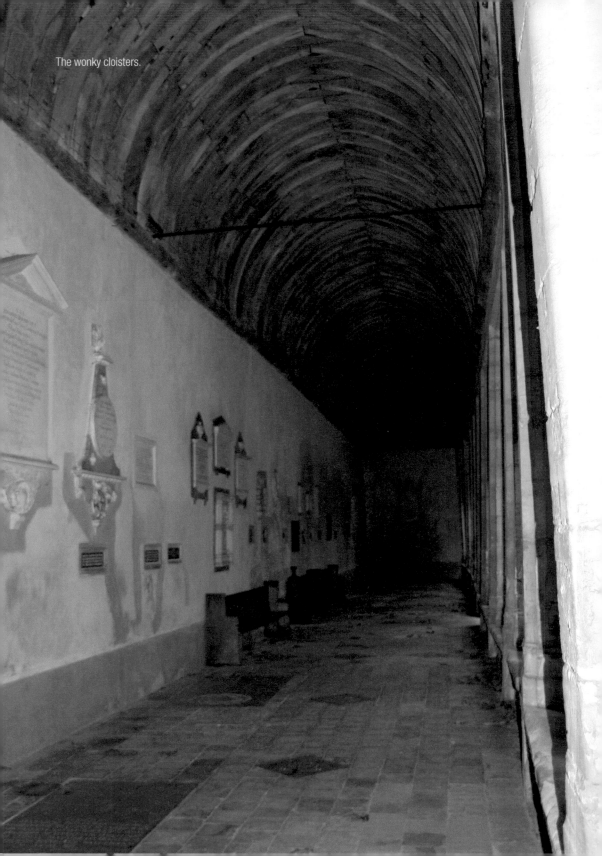
The wonky cloisters.

built five years after the chapel and surround the large Fromond chantry, built in honour of John Fromond, who left money for the chantry to be built and for Masses to be sung for his soul; he died in 1420. The chantry is now used as a library, which has the distinction of being the only chantry in England in the middle of a cloister.

The history of the college is to be found in the cloisters; for example, in the graffiti carved into the soft stone and the memorials that decorate the walls. The initials T.H.O. are particularly well preserved. They were carved by Thomas Ken (1637–1711), who became the Bishop of Bath and Wells. He is famous today for his hymns and for refusing to accommodate Nell Gwynn in his home. Memorials to such famous names as mountain climber George Mallory (1886–1924) line the cloister walls and reveal the prestige of the college.

In the scholar's dining room, looking a little like a miniature version of the dining hall from Harry Potter's Hogwarts, the square wooden-plank plates are still there. The origin of the saying 'a square meal' is supposed to be based on these basic dishes. Nowadays, they are used for toast, which is piled up for the scholars to help themselves to at breakfast time. Another tradition still observed is that of serving a small glass of cider to the scholars on Sundays; the Commoners do not share this indulgence.

'The Trusty Servant' is a curious picture, painted by John Hoskyns, who came to the college to study in 1579. The painting is of the best kind of servant: he has large ass's ears with which to listen; a padlock on his mouth to keep him silent; the head of a pig, which is cheap to feed; a clean and presentable appearance, even when keeping busy with housework; the hooves of a deer to

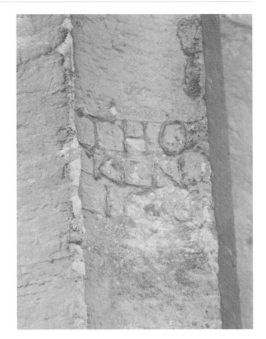

Seventeenth-century grafitti by Thomas Ken. He later gained fame as a writer of hymns and as the person who refused lodging to Nell Gwynn.

make him speedy. Best of all, his open hand denotes his faith. He is dressed in the livery and tunic of the House of Windsor, painted on by William Cave in 1809, in honour of a visit from the Hanoverian King, George III, in 1778. The school motto completes the picture: 'Manners Maketh Man'.

On one side of the painting is a Latin verse and on the other side is the English translation:

A Trusty Servant's portrait would you see?
This emblematic figure well survey,
The porker's snout, not nice in diet shows,
The padlock shut, no secrets he'll disclose:
Patient, the ass his master's rage will bear,
Swiftness in errand, the stag's feet declare;
Loaded his left hand apt to labour saith;
The vest, his neatness, open hand, his faith;

Girt with his sword, his shield upon his arm,
Himself and master he'll protect from harm.

A tour around Winchester College provides a brief glimpse into the medieval world of William of Wykeham, with sights that captivate twenty-first-century eyes.

Wolvesey Castle

When you look at the sorry ruins of Wolvesey, it is hard to believe that this was once one of the grandest of castles. Nearly a thousand years of history has gone by since 1130, when Bishop Henry de Blois began to add to an earlier residence on the site. This was once the location of the old Bishop's Hall, built between the Oldminster and the south-east portion of the Roman wall, and bordered by the Nunnaminster. It was built by Bishop Ethelwold (d. 984). Bishop Gifford (Bishop of Winchester 1107–1129) built over this hall and it was this building, the West Hall, which was standing when Henry came along.

Henry de Blois was an ambitious man and built Wolvesey accordingly. The name means Wolf's Island and refers to the fact that the castle was built on higher ground between two streams of the River Itchen. It was a castle of thirty-eight rooms on four storeys, all arranged around a central courtyard. Henry was building at Wolvesey for over forty years. He added the East Hall first, which was the public audience chamber and, at 27m in length, it was more than impressive. It was later moved up to the first floor. Next, the tower, the keep, two gatehouses and a surrounding moat, which was heavily fortified, were added.

This was a time of great unrest, as cousins Stephen and Matilda vied for supremacy, and for the English crown. Henry, William the Conqueror's grandson, was originally his brother Stephen's supporter and had helped to get him the crown. However, he had not received the reward he had hoped for (the Archbishopric of Canterbury), and so had gone over to Empress Matilda's side. This was to have major consequences for Winchester in 1141. Alienated by Matilda's attitude, Henry then transferred his allegiance back to Stephen and laid siege to Matilda in Winchester. After her defeat, which, according to some reports, involved the destruction of the Conqueror's Palace and forty churches, it must have been hard for Henry to maintain his authority in the eyes of King Stephen. A turncoat bishop needed defenses at home, just in case.

A trip around the Wolvesey Castle ruins is fascinating. The site of Wymond's tower was originally the latrine block and is still standing; the newer outer casing can still be seen and the defensive arrow slits in the walls are visible too. The outline of the East Hall is still apparent and gives an idea of how big and impressive it must have been.

Over the next five centuries Wolvesey Castle was the home of a succession of bishops and royal figures. After the West Gate royal castle was damaged by fire in 1302, royalty took refuge at Wolvesey. Looking at the list of those who resided in Wolvesey, it is difficult to understand its decline: William of Wykeham received Richard II and Henry IV here; Henry V met French ambassadors in Wolvesey before the battle of Agincourt; Mary Tudor met Philip II of Spain here prior to their marriage in 1554. Gradually however, Wolvesey fell out of fashion and into decline. It was expensive

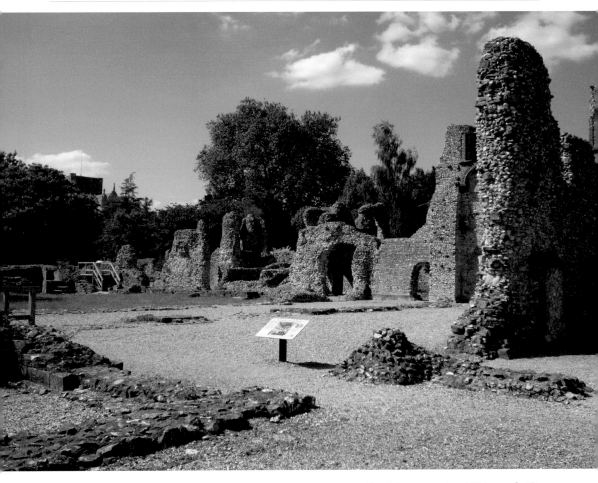

The picturesque ruins of Wolvesey Castle.

to maintain and its stone was useful for repairing roads and walls – an inglorious end. This looting was still going on in the late eighteenth century.

Wolvesey Castle was chosen as the setting for the 1908 Winchester National Pageant, organised to raise money to save the Cathedral from collapse. The National Pageant ran for five days from 25 June. The pageant master was actor F.R. Benson and he mobilised a large proportion of the population of Winchester to produce a spectacular event that told the story of the city in nine episodes. Music was specially written and costumes produced; those who could act did so, regardless of their standing in Winchester. It was an epic effort and, in the end, it produced £3,000 for the Cathedral's fund, which needed every penny. Wolvesey Castle is now in the care of English Heritage.

Wolvesey House is all that remains of the baroque palace, most of which was pulled down by Bishop North in the

1780s. Since 1721, the bishop had lived in Farnham and there was little use for the palace anymore; money was the main problem – it was expensive to maintain. Wolvesey House is a pleasant, mellow brick, two-storey residence, with a deep cornice and curved pediments over the windows. It is the surviving west wing of the palace, designed by Sir Thomas Fitch (*d.* 1688) for Bishop Morley. It faces south and sits beside the Bishop's Chapel, which has Norman foundations and is still in use. This house has been the home of the Bishop of Winchester since the splitting of the diocese of Winchester in 1927. Bishop Thoedore Woods moved from Farnham to live in the newly renovated building in 1928. Today, it is the home of the present Bishop of Winchester, Michael Scott-Joynt, although he will retire in 2011, having been in his position since 1995.

St Peter's Church, Chesil

Chesil was a bustling area in the nineteenth century; St Peter's Church, though, has stood in Chesil Street since at least 1148, when it was mentioned in the *Winton Domesday*. The font in the church dates from the twelfth century but, as there was no burial ground, parishioners were buried on St Giles' Hill.

There is a story that the owner of the house next door in the nineteenth century, one Dr Earle, cut a hole through the wall from his home to the church, so that his aged mother could hear the sermons going on in St Peter's. This also allowed general noise from the house to permeate through to the church, so, in 1897, the rector walled the hole back up again.

After the Second World War, the building fell into disrepair and the Winchester Preservation Trust was formed in the 1960s. Its first duty was to save the church from dereliction. The Winchester Dramatic Society moved into the building rent free, on condition that it maintained the property. The costs to keep the church going as a theatre is £7,000 a year, a sum which is met, in part, by grants from the City Council and Hampshire County Council, but mostly from the considerable efforts of its members.

The Winchester Dramatic Society has over 200 participants and is a member of the Little Theatre Guild of Great Britain and the National Operatic and Dramatic Society. It produces six plays a year, as well as running after-school workshops for children.

Chesil

It is thought that the name Chesil is a corruption of Cheese Hill, named after the cheese fairs held on St Giles' Hill. However, it is also likely to be a corruption of the Anglo-Saxon word *ceosel* (meaning gravel), and referring to the River Itchen's beach, where the ships coming up river from Southampton landed.

It is hard to believe today that there was once a very busy railway station at Chesil; this was on the Didcot, Newbury and Southampton railway line. The pedestrian walkway from Chesil Street, by the Old Rectory, to the Chesil multi-storey car park is called Old Station Approach, which is a clue as to the site's former use.

The station opened in 1885 and the tunnelling through St Giles' Hill, to get to the

station, took a lot of heavy engineering and sheer hard graft. In 1891 the station was linked up to the London and South Western Railway, and became very busy indeed. During the First World War, the station saw troop trains leaving and ambulance trains arriving.

In 1923, the Didcot, Newbury and Southampton line merged with the Great Western Railway, thus giving a greater choice of destination to its passengers, but it was closed in 1960 when passenger numbers declined. Today, if you look, you can still see traces of the old line behind both the car parks in the area. The old tunnel through the hill is still visible, though it is closed up and partially overgrown; the hillside retaining walls are still in place, holding the great mass of hillside back from the road that was the railway track bed.

The Soke

The Soke is the area of old Winchester that was not formally under the jurisdiction of the City Corporation. Instead, it came under the remit of the Bishop of Winchester and was free of the city's trade restrictions and tariffs – an attraction for Wintonians of the Middle Ages. This state of affairs continued until 1835.

The Old Rectory still stands on Chesil Street, although these days it is the first building on the corner with Bridge Street, rather than being several houses along. This change followed the widening of Bridge Street in the early years of the twentieth century to allow for military vehicles during the First World War. The house, now a restaurant, is a charming relict of fifteenth-century Winchester. It was the rectory of

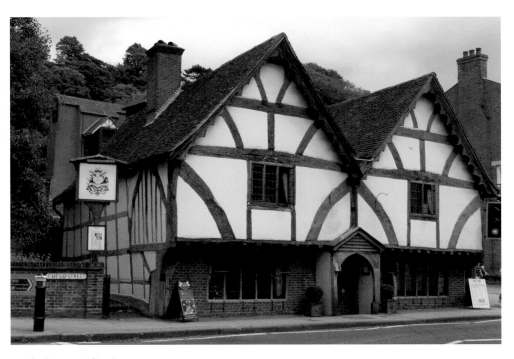

The Old Rectory in Chesil.

St Peter Chesil after the Reformation. In 1892 Messrs Thomas & Co. acquired it in a derelict state and restored it to use as a furniture shop. Winchester City Council bought it in 1932.

Saint John the Baptist Parish Church still stands in St John's Street, as it has done since the twelfth century. Its site is that of a fourth-century Roman-British cemetery. It is known to have existed as long ago as 1142, when Jocelin de Bohun, the Archdeacon of Winchester, appointed the prior and canons of St Denys' Priory in Southampton to oversee it. At that time, the church was a simple cell; the north and south aisles were not added until 1179–1189. It is thought that William of Wykeham, who had established a small school on St Giles' Hill prior to his foundation of Winchester College, initiated a connection with this church. What is certain is that Winchester College scholars came to the church before the college chapel was completed in 1395. Saint John the Baptist Parish Church was one of the churches on the road to London and also to Canterbury, making it important for those making the pilgrimage to Canterbury Cathedral.

From St John's Street it is possible to see the magnificent Sarsen stone, which is set into the wall at ground level. A Sarsen stone is silicified sandstone, the result of an ice age; it is smooth, durable and quite rare. Sarsen stones can be seen at points all over Winchester and they were popular choices for foundation stones (particularly for churches), marker points and safety bollards. The one in the wall here is green with age.

The church is the oldest in Winchester and is made of flint with stone dressings,

and it has a tiled roof. The tower in the south-west corner has walls that are 7ft thick in parts. Originally, there would have been paintings on the walls of the church, but the Victorians did their best to destroy them in 1854. The north wall, however, does still contain thirteenth-century paintings, which were discovered in 1958 when two lancet windows were found. Their splays are beautifully decorated with pictures of St John, St Christopher and various bishops.

Inside the church, in the fourteenth-century rood screen, is a very rare example of 'elevation squints'. These are small peepholes cut into the screen to allow children to see the proceedings during Mass; they are peculiar to Hampshire. The east window, in the south aisle, contains fragments of glass dating from the fourteenth century, when William's scholars worshiped here. The medieval reredos contains Victorian figures.

Some of the monuments are of interest, such as the tablet remembering William Moss, who died in 1790; it includes the telling inscription, 'religious without enthusiasm'. The inscription for Mary Stevens, dated 1763, refers to her husband, Lewis Stevens: 'late of ye island of St Christopher'. This refers to the island more commonly known today as St Kitts, in the West Indies, and may refer to Lewis being a sugar plantation owner. Daniel Forshaw restored the church in 2006.

On the same street is the pretty Tudor House, with its jutting out first floor. This house is remarkable for its ground floor, which is built half of timber framing and half of stone. The attractive plinth is built of ashlar and flint chequered squares.

The eye-catching house known as the Blue Boar is the oldest surviving home

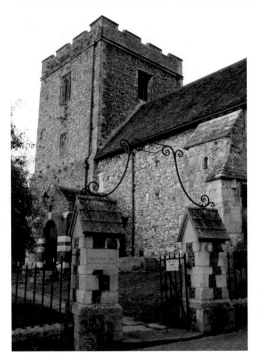

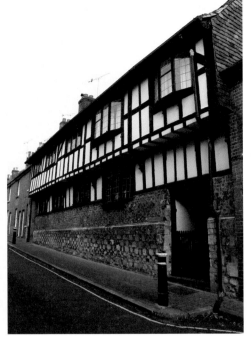

Saint John the Baptist Parish Church, the oldest church in Winchester. The sign for the Pilgrims' Way is visible.

Tudor House in St John's Street.

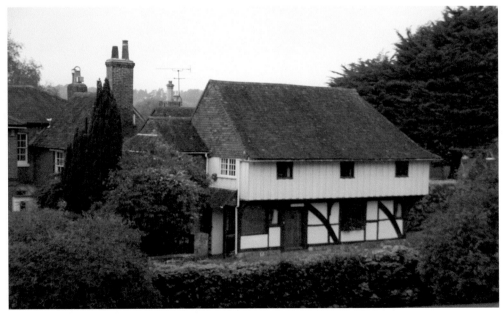

The former Blue Boar public house.

in Winchester. It stands on the corner of St John's Street and Blue Ball Hill, and it has been dated to about 1340; by 1774 it was no longer used as an inn. It retains a central galleried hall, which is open to the roof. In 1970 it was subject to a complete revamp by James Ashby, who has specialized in restoring ancient buildings. The Blue Boar is opposite the tiny Joyce Garden on Blue Ball Hill, which offers a superb view of the city.

The City Mill and Bridge

The City Bridge, over the River Itchen, has been standing since the time of St Swithun, during his stint as Bishop of Winchester between 852 and 862. This point is at the bottom of the chalk valley and is a most convenient place to cross the swirling current. The present bridge dates from 1813.

The river originally flowed in two channels near the Cathedral. In AD 70, when the Roman city was founded, an artificial channel was created. The river here was a natural defense to the east of the city, and the Roman city wall and East Gate benefited from its proximity.

The river has always been very important to the city. The public water supply is extracted from the River Itchen and from boreholes at Otterbourne and Gater's Mill. From the twelfth century, the river was navigable from Southampton Water to Alresford; barges used this route to bring the stone for the Cathedral. The seventeenth-century Itchen Navigation canal transported the water through seventeen locks, between Southampton and Winchester. It closed in 1869 but today is used for recreation; it is a common sight

to see teams from the Winchester College Rowing Club ploughing through the narrow channel.

The City Mill, formerly known as the Eastgate Mill (there is a plaque nearby showing the arms of East Gate) is a rare surviving urban corn mill, which was rebuilt in 1743 by James Cooke, on the site of earlier mills dating back to the reign of King Richard I (1157–1199). The mill has been used, over the years, not just for milling corn, but also for providing power for tanning, fulling (the processing of wool) and papermaking. Until the Reformation, the priory of Wherwell, near Andover, owned the mill. Queen Mary (1516–1558), following her marriage to King Philip of Spain, gave the mill to the city by royal charter in 1554. It was at this point that the name was changed to the City Mill. The river runs under the mill, powering the wheel, and continues on to the point known as the Weirs. In 1820 the mill was sold to John Benham and it was in use until the early twentieth century. Sara Dick-Read (1993) notes that, between 1909 and 1916, the mill was run by Mr Cox and owned by Mr Benham, no doubt a descendant of John, who turned the mill into a laundry when Mr Cox moved on. Economic times were hard in the 1920s and the mill was sold in 1928; it was used as a youth hostel from 1931 and is now owned by the National Trust. In 2004 the organisation undertook a restoration project that saw the resumption of flour grinding and the mill is now part of a rich educational programme, which teaches about milling and the abundant wildlife in the area.

Alongside the River Itchen, just down from the mill and the bridge, are the Riverside Gardens. Here were the eastern

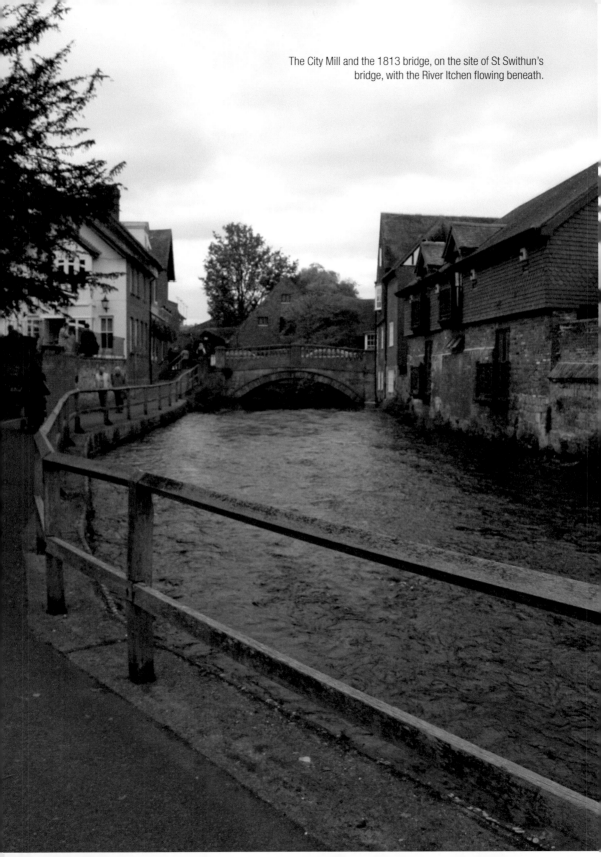

The City Mill and the 1813 bridge, on the site of St Swithun's bridge, with the River Itchen flowing beneath.

boundary walls of the Roman town and today there is a pleasant walkway by the water's edge. Along the walk, the last remains of the old third-century Roman Wall can be seen; it once enclosed an area of 144 acres. A helpful plaque nearby alerts the eagle-eyed visitor to this site.

Further along this walk is a well-preserved section of medieval wall; again, a helpful sign advises the visitor of its presence. The walk goes along to the Weirs, where the river is shallow and fast flowing, and on to the ruins of Wolvesey castle.

Alfred the Great

If you stand at the lookout on St Giles' Hill and look down into Winchester, the towering statue of King Alfred the Great, at the lower end of the Broadway, is an imposing sight. It was designed by Hamo Thorneycroft RA and was erected in 1901. Hundreds turned out to see the unveiling of the statue of Wessex's greatest leader, and the Bishop of Winchester made a speech. Alfred is depicted wearing his crown and with his shield on his arm; he symbolically holds aloft his upturned sword. Thorneycroft has shown Alfred as he was – a devout Christian and a warrior.

Alfred was born in Wantage in Berkshire in AD 849. His father, King Ethelwulf, meaning 'noble wolf' (AD 806–856), had succeeded his father, King Egbert, in 837, who himself had seized the Wessex throne after the death of Beorhtric, who had ruled between 786 and 802.

King Ethelwulf had proved to be a good ruler, despite his ecclesiastical leanings. On his death, he left a tenth of his land to the Church; the deed for this was written in Winchester, which grew in importance during this period. Ethelwulf was succeeded by each of his sons, Ethelbald (AD 850–860), Ethelbert (AD 860–865) and Ethelred (AD 865–871). Their reigns were plagued by attacks from the Danes, who had invaded England in the eighth century and were intent on conquering as far as they could. The Norsemen had made peace with the East Angles and the Mercians, and now they wanted Wessex. King Ethelred and his brother, Alfred, defeated them at a fierce battle at Ashdown, near Lambourn in Berkshire, in AD 871, but they were defeated at Basing, in Hampshire, two weeks later. Ethelred died soon after this battle, leaving Alfred to rule in his place.

Alfred was crowned King of Wessex in AD 871. He made Winchester his capital, thus ensuring its place in history. The Danes had not gone away after winning at Basing, so life was not quiet for the young king. Over the next eight years, Alfred found himself almost constantly at war to keep his kingdom. It was during this period that the best known story about him is set, although it was not in circulation until nearly four centuries later and is not mentioned by either of the leading primary sources for the period, the *Anglo-Saxon Chronicle* (AD 890), the book Alfred himself commissioned, or *The Life of Alfred the Great* (AD 893) by Asser, the Welsh monk.

In the winter of AD 877–878, the Danes controlled a large part of Wessex. Alfred withdrew to Athelney in Somerset. Here, so the story goes, he took refuge in a lowly cowherd's hut. Unrecognised by the local people, he was asked to keep an eye on the cakes baking in the housewife's hearth. He was, however, preoccupied with seeing to his equipment and so he forgot the baking

Hamo Thorneycroft's statue of King Alfred the Great.

and the cakes were burnt. The housewife scolded him vigorously and the story has become a defining one for Alfred. He later commanded the building of a monastery at Athelney.

After the Battle of Ethandun in AD 878, which Alfred won decisively, the Danes were starved into submission in Chippenham; it was the beginning of a period of peace for Wessex. The Danish leader, Guthrum, converted to Christianity and Alfred and Guthrum agreed to split their territories between them in the Treaty of Wedmore. Guthrum brought Danelaw to East Anglia, but Alfred retained the mints in London. All was uneasily quiet for several years, but the Danes chafed at the bit and Alfred had to retake London in about AD 886. It was at this time that he styled himself King of the Anglo-Saxons.

Alfred was under no illusions; he knew that there were more Vikings waiting to sail to England and he looked to shipbuilding to repel them. He established shipyards, building ships larger than the esks that the Vikings sailed in. These had sixty oars, twice the number of the enemy craft. These small beginnings were arguably the basis for the navy. In AD 897 these ships were engaged in a battle in the Solent. Both sides sustained heavy casualties but Alfred's fleet eventually emerged victorious.

Alfred himself was a very pious man and was devoted to education, although according to Hone, he did not learn to read until he was twelve. He surrounded himself with learned men, nicknamed 'Alfred's scholars', who were there to help him with his quest to spread learning in Wessex. Among them was Asser, the Welsh priest of St David's, whose *Life of King Alfred the Great* is now of great value to us in twenty-first century Britain. Asser spent half of the year with Alfred's household and, as Barry Shurlock (1986) points out, his work is the first biography of a lay Englishman. Others with Alfred were Plegmund, a Mercian cleric who became the Archbishop of Canterbury; Werferth, later the Bishop of Worcester; Grimbald of St Omer; John, described as a continental Saxon.

When Alfred died in about AD 899, he was buried in the Old Minster in Winchester. However, his body was moved to the New Minster and subsequently to Hyde Abbey, in 1110. His final resting place was respected until the Reformation, when the buildings were pulled down on the orders of Thomas Wriothesley, the Earl of Southampton. However, he did not disturb Alfred's tomb. It was in AD 1787–1788, when a gaol was built on the site of the abbey, that Alfred's remains were to scatter in the winds. Alfred's simple stone grave marker was discovered in a St Peter Street garden in the eighteenth century and is now in the City Museum.

Alfred split his kingdom up and left parts of it to each of his children in his will. He is remembered every year in the Anglican Church on 26 October.

EAST GATE TO HYDE

St John's Winchester Charity

T IS not clear exactly when St John's Hospital was founded. According to Barbara Carpenter Turner (1992) the monks at Hyde Abbey commemorated Bishop Brinstan each year as its founder. He was Bishop of Winchester from 931 to his death, in 934. The hospital began life as the St John the Baptist Chapel and St John's House. The house was used to give help and care to the old and infirm, to needy travellers and to poor men and women, usually those recommended by the City Corporation.

Saint John's was a powerful institution. The Mayor of Winchester was sworn into office in the chapel. The Corpus Christi procession left from St John's House and the Fraternity of St John met there. Corporation meetings were held at the house and the chest containing the records was stored there. All property transactions were noted at St John's and the authenticating seal was appended there.

The master of St John's, who was later often the chief chaplain, was known as the *magister* (master), and the warden was known as the *custos* (guard). To hold the *custos* position was equivalent to holding a civic appointment. Saint John's derived its income from rents; several shops and properties paid rent, in particular those businesses on St Giles' Hill.

During Henry VII's tempestuous reign, St John's managed to hold on to both its chapel and its wealth, as they were not listed as religious institutions, but as charitable ones. A legacy in 1558 by Ralph Lamb enabled the building of the first almshouses. In 1587, the hospital was brought under the control of the Mayor and the City Corporation, an act enshrined by charter. The chapel was turned into a free school some time after 1701.

There were enquiries made into the finances of St John's Hospital in the nineteenth century because the City Corporation were using the revenues for services other than the hospital. As a result, thirteen trustees were appointed in 1829. This led to an improvement in the conditions for those living in St John's Hospital when the St John's South almshouses were opened in 1834.

King John's House, with its distinctive painted-on windows.

Today, St John's House, at the bottom of the Broadway, is partly thirteenth century, but the first and second floors are from the eighteenth century. If you look up you will not notice anything amiss unless you look hard. It is then that you will see that the second-storey windows are not windows at all! They are painted onto the walls, complete with a paint pot and brush in one, supposedly open, window.

The city-based charity, renamed St John's Winchester Charity, runs several of the city almshouses, including the St Mary Magdalene houses down by the Weirs in Colnbrook Street, St John's North and South on the Broadway and at Christies' Hospital in Symonds Street. These last were the result of the legacy left by Wintonian mercer Peter Symonds (c. 1528–1587).

The Fire Station

The fire station has stood on North Walls since 1937. Today it is about to pass into Winchester's history as it has been sold to make way for development. The building is no longer considered capable of keeping up with the needs of a modern-day fire service; a station that can stay open continuously, accommodating more than forty fire fighters, is needed. A new, larger fire station in Winnall, nearer to the M3 and the A34, was in the process of being built as this book went to print. It will also be a road-safety training establishment and the building will be environmentally friendly.

About to become history – the Winchester Fire Station.

Friarsgate and Eastgate Street

The Lion Brewery was situated on Eastgate Street. Peter Punton operated it until 1880, after which time Frances Hill Punton ran it. There was also a Lion Brewery premises in St James' Lane until Wootton & Co. acquired it in 1887. The same company then purchased the Lion Brewery in 1895; it became the Lion Brewery (Winchester) Limited in 1906. In 1931 Strong & Company of Romsey Limited purchased the Lion Brewery and it then ceased to brew. The premises became a bakery and remained so until the 1960s, when it was redeveloped into council flats as part of the creation of Friarsgate.

The Gates

Winchester had five city gates set into the city wall: King's Gate, South Gate, East Gate, West Gate and North Gate. Of these only two survive: the West Gate and the King's Gate, near the Cathedral Close. The 1736 engraving by Nathanial and Samual Buck, called 'The East Prospect of Winchester', shows the South Gate, East Gate and North Gate. The engraving shows that there was a bowling green on what is now the North Walls. North Gate was still standing at that time.

The junction of Jewry Street with Hyde Street was the site of the old North Gate, marking the beginning of the Roman road to Silchester. Just beyond this was the site of a Roman burial mound, commemorated by an informative plaque nearby. North Gate collapsed in 1755, on to a christen-

ing party travelling through it, and was then demolished. The Paving Commission pulled down South Gate and East Gate soon after.

The Counting House

The Counting House is on the corner of Hyde Street and Marston Gate. Now a three-bedroom private house, this was originally the front office of the Winchester Marston Brewery and was built by Thomas Stopher in 1907. It retains its beautifully etched windows and ornate front door with overhead pediment and Art Nouveau grilles. The cellar contains a date stone showing that brewing began in the early eighteenth century; this practice continued to 1925. The premises were part of a distribution depot until 1997.

Hyde House

Hyde House is a fine example of a Tudor townhouse. The surviving brick building, with its charmingly uneven roof, was part of a wing of the original mansion. It has a Flemish gable end and a blank Ionic doorway. It was built on part of the old Hyde Abbey site in the sixteenth century for Richard Bethell, who had purchased the land from Thomas Wriothesley after the abbey had been plundered and demolished on Henry VIII's orders.

The house had a walled garden, which extended down to the River Itchen and was owned, in the late seventeenth century, by the Pawlett family; Essex Paulett left orders in his will that the house should be sold after his death.

In 1721 Daniel Defoe noted that Benedictine monks were living at Hyde House. In their 1736 engraving, 'The East Prospect of Winchester', the Buck brothers, Samuel and Nathaniel, show the house, complete with a walled garden and a gazebo. A stone barn replaced the house in 1769.

Hyde Abbey

Hyde Abbey was built on the orders of Henry I (1100–1135) to help ease the cramped conditions of the New Minster site, which was then demolished; the site became part of the Cathedral churchyard. He chose a green field in the northern part of the city and built an impressive building that was one of the great medieval abbeys.

Hyde held the bones of King Alfred, his wife Ealhswith of Mercia and his son Edward the Elder, as well as other relicts. Indeed, the monks from the New Minster brought the remains of the royal family to the abbey in procession through the streets to Hyde Abbey in 1110.

The abbey was burnt down in 1141, during the struggle between the forces of Matilda and Henry de Blois. The church was rebuilt in 1196, with collections towards its completion still being sought by Bishop Woodlock in 1311.

In the Register of Bishop Edington (d. October 1366), Pope Clement VI requests 'payment for produrations' for the expenses occurred by Nicholas, the Archbishop of Ravenna, who, it is stated, was sent on 'difficult business' to King Edward III in 1345. The bill was for £138 2s 6d and was paid by the Archbishop of Canterbury. He then decreed, in an entry

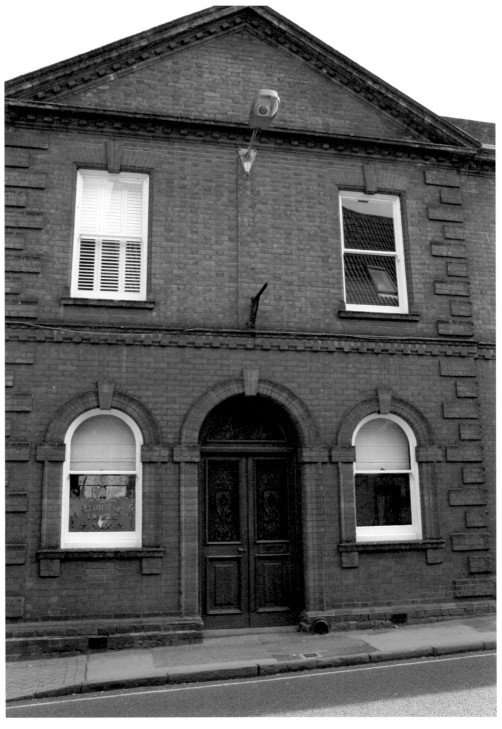

The Counting House in Hyde.

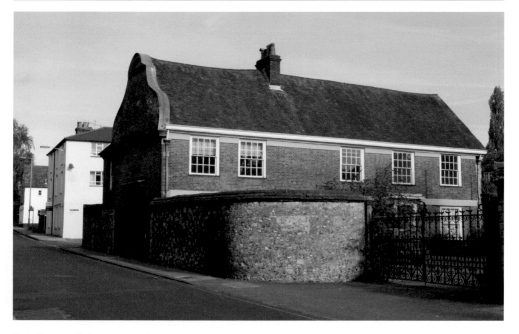

Hyde House, with its uneven roof.

in the register dated 17 February 1346, that there should be a levy paid from all those clergy who had benefited from Nicholas' visit. The Abbot of Hyde was deputed to collect the levy, in farthings, from the Archdeaconry of Winchester and to deliver the money to the Bishop's house in London. According to the record in the Register on 27 April 1346, he performed these duties accordingly.

By all accounts, the abbey was not a happy place. Firstly it was affected by the Black Death. Also regular squabbles with the bishops and the Corporation of Winchester occurred, as well as between the abbey tenants. Finally, a fire in 1445, which deprived the building of its bell tower and the eight bells within it, did not help matters.

As Barbara Carpenter Turner (1992) points out, little is known of the layout of the abbey buildings. There were three main areas surrounded by a precinct wall: the forecourt, the inner courtyard and the main monastic enclosure. As the abbey was the first stop that pilgrims would pass on the way to Canterbury Cathedral, the public forecourt would have been a busy place; it was both the site of the parish church and also a market area for the pilgrims to buy provisions to take with them on their journey. Today, the Hyde Gate is all that remains of the entrance to the inner courtyard, the service area of the monastery.

The gatehouse is a rectangular building, dating back to the fifteenth century, facing north-east by north. The west side is the entrance passage; the east side has two storeys and was possibly the porter's lodging. Wide arches, with moulded outer orders, span the passage, while the inner arches are plainer.

1 Speed's map of Hant Shire, 1611.

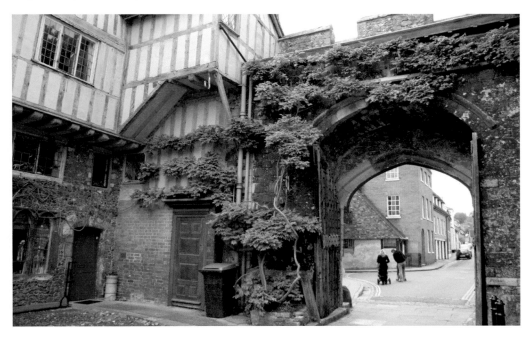

2 Through the Priory Gate, at Winchester Cathedral, is the Church of St Swithun. On the left-hand side is the Sarsen stone and inside the gate is the Porter's Lodge. (By kind permission of the Dean and Chapter of Winchester Cathedral)

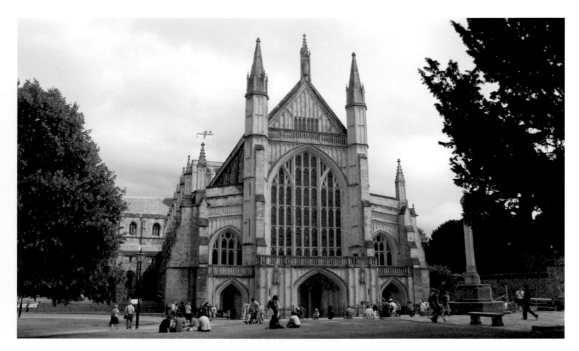

3 The majestic Winchester Cathedral: a thousand years of history encapsulated in one building. Allow several hours for a visit, as there is so much to see. The lawns to the front of the main entrance, which are now used by visitors for picnics, were once a graveyard. Some of the tombs are still there. (By kind permission of the Dean and Chapter of Winchester Cathedral)

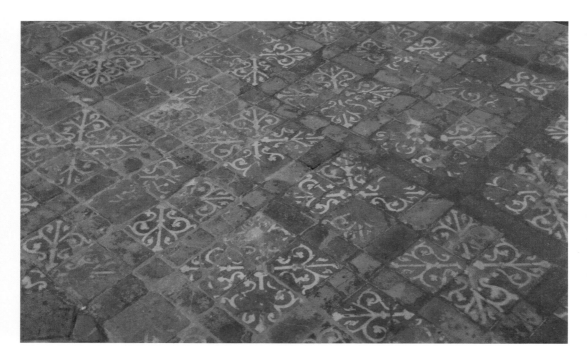

4 The medieval glazed tiles inside Winchester Cathedral. It is amazing to think that these are still fit to walk upon, although respect for their age is encouraged. (By kind permission of the Dean and Chapter of Winchester Cathedral)

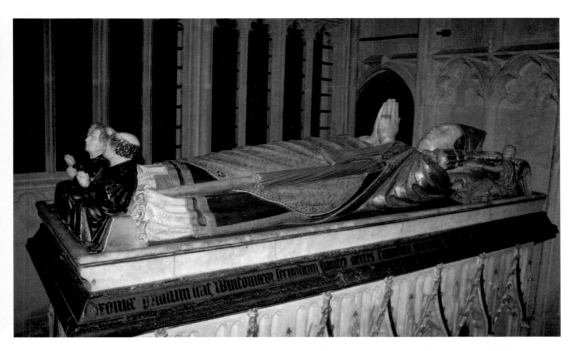

5 William of Wykeham's chantry. This chantry, in the nave of Winchester Cathedral, was renovated by members of Wykeham's Winchester College in 1894–97. The figures at the foot of the effigy are thought to be those of Wykeham's executors. (By kind permission of the Dean and Chapter of Winchester Cathedral)

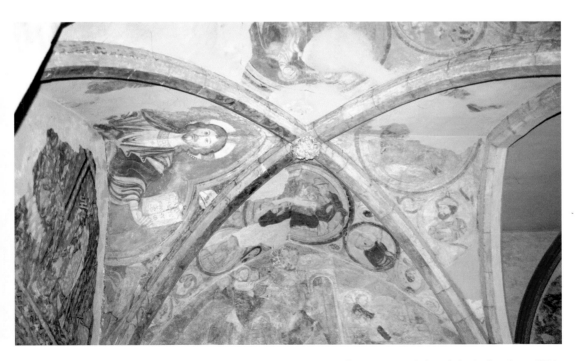

6 Winchester Cathedral's Holy Sepulchre Chapel. This tiny chapel is filled with Romanesque paintings dating back as far as 1220. (By kind permission of the Dean and Chapter of Winchester Cathedral)

7 Subsidence in the crypt; evidence of
the major problems the Cathedral faced
is visible. As you can see, movement
was severe and for the continued
survival of the building, drastic
measures had to be taken. Underpinning
and the introduction of buttresses were
to save the Cathedral from collapse.
(By kind permission of the Dean and
Chapter of Winchester Cathedral)

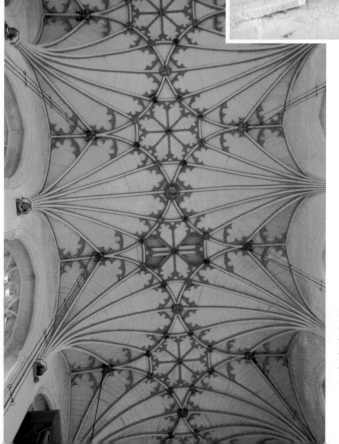

8 The beautiful traceried ceiling in the
chapel at Winchester College is one of
the earliest of its kind. It dates originally
from between 1387 and 1395, when
the chapel was built. It was repainted in
1952 using the original colours.

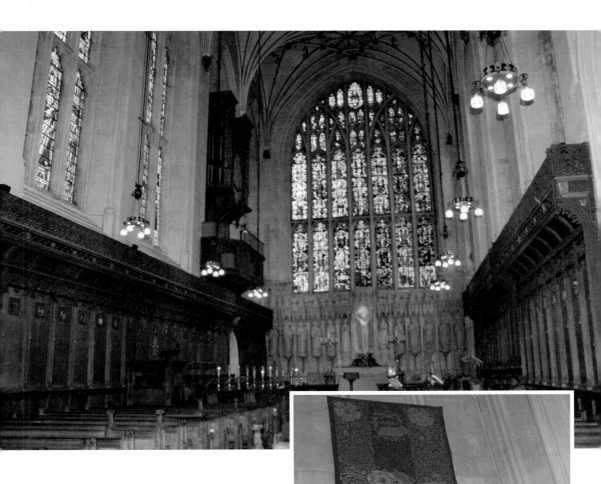

9 The Victorian east window and the reredos beneath in the Winchester College Chapel. The panelling and pews date from 1913–21.

10 The Rose Tapestries in the Winchester College Chapel. They depict the White Rose of the house of York and the Red Rose of Lancaster. The Wars of the Roses ended with the marriage of Elizabeth of York and Henry Tudor (Henry VII).

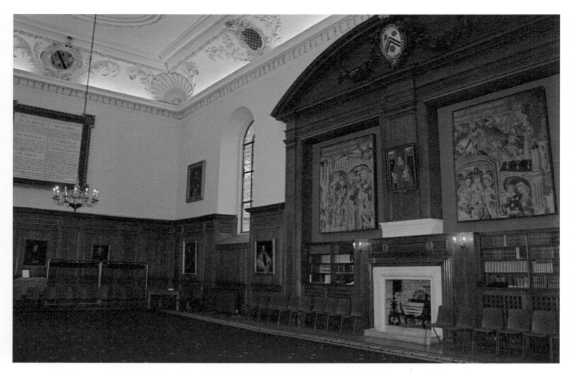

11 The school building at Winchester College – this beautiful room features the tapestries woven to remember Mary Stuart's marriage to Philip of Spain.

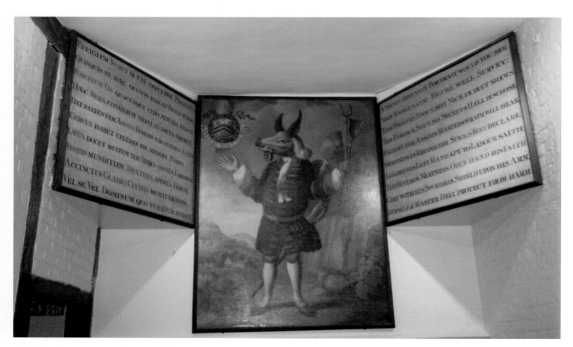

12 'The Trusty Servant' – a depiction of what an ideal servant would look like. It was painted by Thomas Hoskyns, who went to Winchester College to study in 1579.

13 The Jubilee Sculpture by Rachel Fenner was commissioned to celebrate Queen Elizabeth II's Golden Jubilee. It stands on the Law Courts Terrace just along from the West Gate.

14 Queen Victoria, by Sir Alfred Gilbert RA, in the Great Hall at Winchester Castle.

15 'The English Gents': Denis Lock and Hamish McCann, two Australian acrobats, who hilariously bare all at the Hat Fair in Winchester. They have performed all over the world, most recently with the Cirque du Soleil.

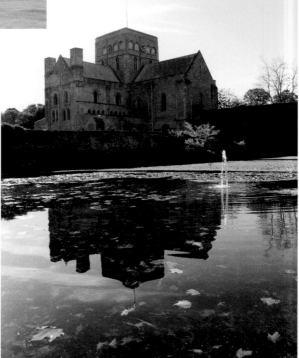

16 A view of the Hospital of St Cross from the Master's Garden.

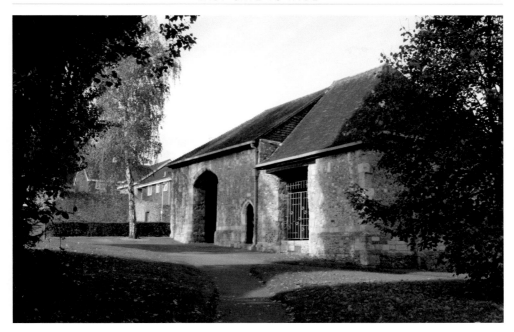

Hyde Abbey, a once great community.

Inside the courtyard, visitors would have found the essential services such as the stables, the bakery and the almoner's hall, where they could seek shelter and alms. The manmade stream (which still runs), spanned by a bridge that has brick-work dating from the twelfth century, divided the noisy public areas from the quiet and sacred centre of the abbey.

The Dissolution of the Monasteries spelt disaster for Hyde Abbey. Henry had defied the Catholic Church to divorce Catherine of Aragon in 1533 and had then inaugurated the Church of England. He set about destroying and plundering the Catholic religious buildings throughout the Kingdom. Hyde Abbey survived until 1538, when the last abbot, John Salcot, sur-rendered to Thomas Wriothesley, who was in charge of the dissolution of Hampshire's

monasteries. Gold, silver and precious objects were plundered and relicts were scattered. Many of the buildings were can-nibalized for their stone, which was used in buildings throughout the city. In 1788, convicts who were building a prison on the site disturbed Alfred's coffin; they stole the lead from it and dispersed the bones from inside.

The property owner, William Barrow Simmonds, Conservative MP for Winchester between 1865 and 1880, gave the abbey to the city and so what was left of it came to be preserved. The 900th anniversary of Hyde Abbey was in 2010; a series of events marked the date. Saint Bartholomew's Church is opposite Hyde Abbey. At the entrance is a large Sarsen stone, marking the boundary to the site.

AROUND JEWRY STREET

Jewry Street

JEWRY STREET gets its name from the Jewish people who lived there from at least as early as 1160 until 1290. The Pipe Roll of the Bishopric of Winchester (1301–2) refers to a fine paid at the time by female Jews for not marrying a Jewish suitor (Page, 1996). However, in 1750 the street was known as Jury Street and before that as Jail Street.

Jews had come across from the large Jewish settlement in Rouen, in Normandy, with William the Conqueror and they settled in London. They set up shops and lent money, which made them rich and powerful, but also led to them being mistrusted and disliked by the local, Christian, population. Some of the settlers moved to the countryside and some moved to Winchester, where they flourished around the area known today as Jewry Street. This led to great wealth, which was not appreciated by those who had to repay loans and who resented Jewish prowess in financial affairs. There was also a Jewish school and several synagogues in the area. Stories began to circulate all over the country, of blood sacrifices of Christian children during Jewish Paschal Rites, which fuelled the rising hatred within the breasts of the local population nearby. In 1192, there was a rumour that a Christian boy was crucified in Winchester, but there are no details to substantiate this story. In the twelfth and thirteenth centuries, there are tales of Jews being executed on the basis of stories like this. However, this was not the case in Winchester; the city valued them as shopkeepers, artisans and craftsmen as well as usurers.

However, King Edward I, trying to bring order to the ruin of the country he had inherited from his father, King Henry III, was assiduous in carrying out an edict from Rome, which called for usury to be declared a sin. This led to great hardship amongst the Jewish population in England. Many took to the illegal practice of clipping coins (clipping a piece of gold from the coins of the day), and melted down the clippings to form bullion, which they sold on. There were huge numbers of prosecutions until, on 17 November 1278, house-to-house searches in Jewish areas

The junction of Jewry Street and High Street. Barclays bank now stands on this busy corner.

Jewry Street.

were held, specifically to arrest Jews. In Winchester, Benedict fil' Licoricia, a prominent city Jew, was arrested and sent to the Tower of London. His property, together with that of all other arrested Jews, was confiscated and escheated to Edward.

On 18 July 1290, by coincidence the Jewish fasting day of the ninth of Ab (the anniversary of many disasters for Jews), the King issued orders for the expulsion of all Jews. All Jewish persons had to be gone from England by 1 November. This edict of expulsion has never been revoked.

Jewry Street, running north to south of the city centre, is a frenetic street today; it has always been busy throughout its long history. The George Hotel stood on the site of the Moon Inn, dating from at least 1408. The Moon's name was changed following the Battle of Agincourt in 1415, when, in honour of King Henry's battle cry (remembered by Shakespeare as, 'God for Harry, England and Saint George!' in his play *Henry V*), it was renamed the George. It was situated at the south of the street, but was sacrificed in 1956, when that end of the street was reworked to accommodate the growing number of cars travelling through the city. Today, the Barclays bank building stands on the altered site, dating from 1957.

This was the street the city gaol was situated on until 1854, when much of the building was demolished after the prisoners were moved to the new jail in Romsey Road, in 1850. During the demolition, a Roman sandstone altar was discovered. It was inscribed with the names of mother goddesses worshipped by Roman soldiers and was, according to Barbara Carpenter Turner (1980), dedicated by Lucretianus, who was the first of Winchester's inhabitants whose identity has survived. What

remains of the gaol can be seen at either side of the congregational church, built in 1853, amongst the largely Victorian buildings in the terrace opposite Barclays bank.

The ground floor of 11 Jewry Street is now the Old Gaolhouse pub, but if you look up you will see the pediment and five-bay frontage of the gaol. It was on the site probably from the thirteenth century, but was rebuilt in 1788 and again in about 1805. The old gaol was the City Museum from 1850 to 1873. It was sold to a banker after this, who put in a shop front at street level in 1876.

Jewry Street held the cattle market (now a car park), and the Corn Exchange (now the library and Discovery Centre). The public library and Discovery Centre is a fine building on this busy street. Owen Browne Carter (1806–1859) designed it; his work in Winchester and reputation as a topographical artist is renowned, and he was involved in the restoration of the Great Hall. The Winchester Corn Exchange opened in 1838. Since 1900 the building, with its classically configured façade, has been used variously as a roller-skating rink, a cinema, a theatre and a library (the library service moved into the building in 1936 after outgrowing its previous premises in the Guildhall). The impressive portico, supported by Tuscan columns, was inspired by St Paul's Church in Covent Garden, built by Inigo Jones. The building was adapted in 2006–7 by Alec Gillies and Martin Hallum of Hampshire County Council Architects, becoming the Discovery Centre.

The mellow building that is now the Loch Fyne restaurant on Jewry Street, has a sign over the entrance dating it to 1509. It is thought that the fireplaces inside are in their original sites and they date from

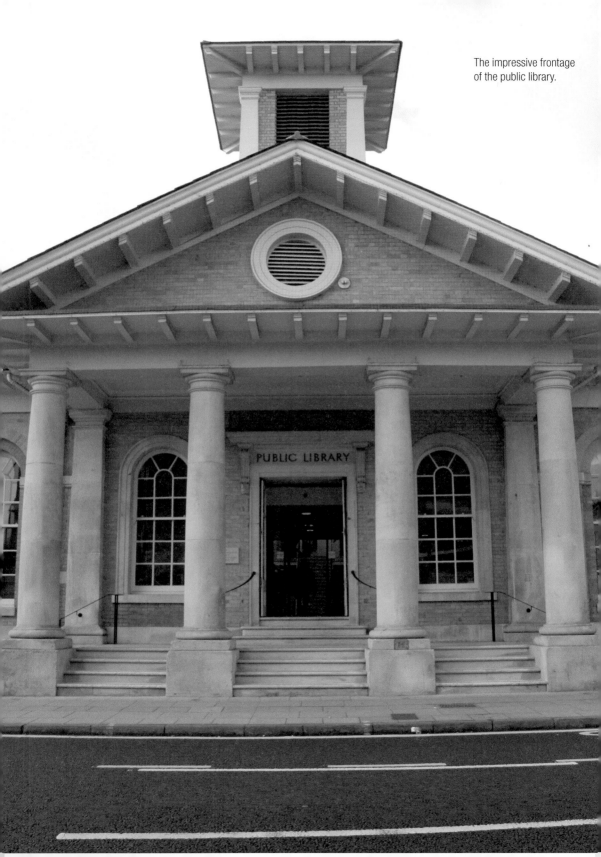

The impressive frontage of the public library.

the sixteenth century. The building was restored in the 1920s.

One entrance to St Peter's Roman Catholic Church stands on Jewry Street. The church is on an imposing site, bridging Jewry Street and St Peter's Street. The church was erected in 1926 and was designed by Frederick Walters in a decorated gothic style. Set into the door of the north wall is the late Norman doorway, dating from 1174, which was the west door of the church for the Morn Hill leper colony on Alresford Road. This colony, at the St Mary Magdalen Hospital, was probably one of Bishop Henry de Blois' foundations. There has recently been much work done by the University of Winchester in excavating the Alresford Road site, which is now arable land, as the last of the hospital buildings was pulled down towards the end of the eighteenth century. It is known that in about 1148 Blois re-founded the leper colony here. There may have been an earlier hospital on the site, but this is not clear. The site escaped the destruction of Henry VIII's reign and in about 1552 the almshouses, made of brick, replaced the medieval hospital structures. Only the original chapel building was left as it had been built. The hospital was used as a camp during the Civil War era and later as a prison for Dutch wartime captives. By now, the original inmates had gone and many of the buildings had been removed. The last buildings, in a ruinous state, were demolished in 1789. What is known of the interior of the last of the almshouses and the chapel comes from a description left by the last hospital master, William Wavell, and from sketches drawn by Jacob Schnebbelie. The University of Winchester excavations have found several skeletal remains, some of which show signs of leprosy.

The Market Hotel on Jewry Street was huge; it demonstrated just how high demand for accommodation was for the traders coming to the city for the markets. It was built in 1850 by Henry Vaughn and possibly designed by Owen Browne Carter. The Simpkin brothers bought it in 1912 and it is now the Theatre Royal. From the outside, the Theatre Royal resembles a smart country house, with its classical Doric pilasters decorating the front of the building.

John and James Simpkins, who had been running the Palace Variety Theatre inside St John's House on the Broadway since 1910, purchased it and transformed it into a variety theatre, which opened in 1914. Its repertoire consisted of live variety shows and silent movies. Grace Stansfield, before finding stardom as Gracie Fields, and Chesney Allen both performed here in 1915. It became solely a cinema in 1920 as a result of the growth in popularity of moving pictures; it remained a cinema for fifty years.

After John died in 1923, James sold the building to County Cinemas Limited, which was later taken over by Odeon and was operated as an Odeon cinema until 1950. From this time until 1970 it was leased out and then sold to the Star Group.

In 1974 the theatre was closed down and the owners applied for a demolition order. The land it covered was valuable and it was more profitable at that time to erect commercial premises on the site. Bejams, the frozen food chain now known as Iceland, were interested in the site for one of their stores. The Winchester City Council responded to this by applying for, and securing, a Grade II listing on the building. There was a strong feeling that there should

Saint Peter's Roman Catholic Church, which has a doorway that was salvaged from the old leper colony on Morn Hill.

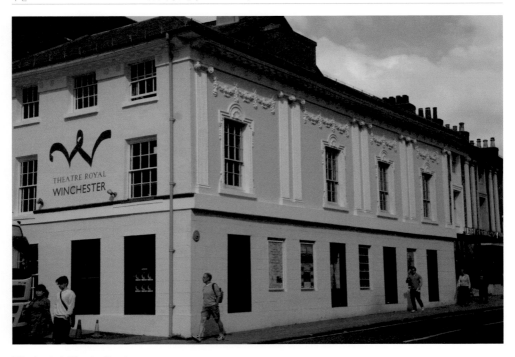

Winchester's Theatre Royal.

be live theatre back in the city and soon the Winchester Theatre Fund was created; its mission, to raise £35,000 to buy the premises. With the help of benefactors such as Peter Cadbury, the Sainsbury Trust and the City Council, this goal was attained in 1977. After extensive refurbishment, involving much fund raising, the theatre opened its doors to the public as a live theatre in 1981. Since then, projection equipment has been added, so it is as the Simpkin brothers had it originally – as a theatre and a cinema. A further five-year extensive renovation was completed in 2001. The theatre is now operated by the Live Theatre Winchester Trust Limited.

Winchester Theatre is reputedly haunted. When the brothers bought the property, John Simpkins was the sleeping partner and his brother, James, ran the theatre. Several ghosts, one of whom is said to be that of John, who died in 1923, reputedly haunt the theatre. Other reported ghost sightings are of a dancing girl, a Victorian lady, and of one of the 'blinders' (the spotlight operators) who had been sent to France in the First World War but appeared to one of the dancers on the night he died.

FROM CLIFTON TERRACE
TO THE PENINSULA BARRACKS

Winchester Workhouse

THE WORKHOUSE was built in 1837 on Clifton Terrace. William Coles, the city surveyor, based the design on plans drawn up by the Poor Law Commission's architect, Sampson Kempthorne (1809–73). It is now residential housing. There were segregated wards for adults, schools for boys and girls, a washhouse, workshops and a central exercise yard. The incinerator chimney has been retained as a landmark, and the later nurses' home from 1912 has also been preserved. The current housing was converted between 1999 and 2000.

The Railway Station

Winchester's surviving railway station dates from 1838–39. Sir William Tite designed it for the company operating the line from London to Southampton, the London and South-West Railway.

Sir William Tite (1798–1873) was a giant amongst architects. It is possible to see evidence of his work all over England and on the continent too. His chief claim to fame was the rebuilding of the Royal Exchange in 1844, in London. However, he is known for his railway stations, as he designed many, including Southampton Terminus, Gosport, Nine Elms at Vauxhall, Edinburgh, and all the stations between Le Harve and Paris, in France. Tite was also responsible, alongside Sydney Smirke (1798–1877), for landscaping Brookwood Cemetery in Surrey. Tite was knighted for his services to architecture in 1869 and was made a Companion of the Bath (CB) in 1870.

The railway station, a two-storey building with single-storey wings, is dominated by the station clock and is characterised by its attractive wood fringe, which decorates the front.

The Hampshire Record Office

In a city that oozes history, it is interesting to note some of the more modern buildings that have been built. They, too, will eventually become worthy of note as an historical

The chimney and the old nurses' home are still on the site of the old workhouse, at the point where Clifton Terrace merges into St Paul's Hill.

The surviving Winchester railway station.

The Hampshire Record Office.

record of Winchester's twentieth-century architecture. One of these buildings is the Hampshire Record Office, on the corners of Sussex Street and City Road. This is the first building of note that the visitor sees when arriving at the Victorian railway station on Station Hill and walking into the city. It is a striking edifice, designed by the Hampshire County Architects Office.

Built on a steep slope (a difficult feature to work with), the building contains vaults that hold the history of Winchester, and indeed Hampshire. There is also an enclosed garden and bright, airy offices and public spaces. The whole thing is arranged in an elegant, terraced structure with huge windows and mellow brickwork.

Hampshire County Council originally established the Hampshire Record Office in 1947. Its mission was the preservation of the County Council archives and those of its predecessor, the Hampshire Quarter Sessions. These included records of Hampshire organisations, families and individual residents. Furthermore, the aim was to make these records accessible to the public. The records of the Wessex Film and Sound Archive were added in 1987.

The Hampshire Record Office moved to its present purpose-built premises in 1993. In 2008 the county Local Studies Library was merged into the collection, to form the Hampshire Archives and Local Studies service, which is funded by the Hampshire County Council.

Elizabeth II Court

The County Hall building was built in 1956–59 by John Brandon-Jones (1908–1999) with his partners Robert Ashton and John Broadbent. Brandon-Jones was a leading authority on the Arts and Crafts Movement and, with John Betjeman, he founded the Victorian Society, a charity that seeks to study and protect Victorian and Edwardian buildings in Britain. One of the members was Sir Nikolaus Pevsner (1902–1983), whose architectural guides, called *The Buildings of England*, continue to be influential. Brandon-Jones was a champion of the work of Philip Webb (1831–1915), known as the father of Arts and Crafts Architecture.

The County Hall building took inspiration from Webb and from Dutch architecture. It surrounds a central courtyard and is of redbrick Flemish bond. The façade has three storeys, gables and a high roof. There is a clock tower and a spire, which can be seen for miles. Bas-relief coats of arms, in Portland stone, by Norman Pierce of the Winchester School of Art, are at the pedestrian entrances.

Next door to the Elizabeth II Court is the offices and parking area of Ashburton Court, built in 1966 by the county architect. In 2006, ambitious plans were set before the Winchester City Council Development Control Committee, to renovate Ashburton Court and join it to Elizabeth II Court. This renovation went ahead between 2007 and 2009, at a cost of £40 million, financed by city asset selling. Over £200,000 a year is being saved in the costs of the buildings, and the aim is that they will make 70 per cent fewer carbon emissions.

The Hampshire Hog

Today, opposite the West Gate, there is a lone Hampshire hog on display outside the Hampshire County Council headquarters building (Elizabeth II Court). David Kemp created this realistic bronze statue to commemorate the centenary of Hampshire County Council in 1989.

Hampshire people are known affectionately as 'Hampshire hogs'. The origins of this nickname seem to have been lost, but there are some clues. Evans (1990) acknowledges in his version of the *Brewer's Dictionary of Phrase and Fable* that the name may have derived from the pigs famously produced in Hampshire.

A hog is a male swine, which is castrated and bred solely for its meat. Hampshire folk have always been proud of the hogs they produce and Wendy Boase (1976) notes that pigs were thought to have psychic powers and would predict windy weather by flinging about the straw in their sties.

The Hampshire government website states that in 1790 the term 'Hampshire hog' had been included in the dictionary and was a 'jocular appellation for a Hampshire man'; the definition linked to the fine pigs and bacon produced in the county. It seems fitting that this statue has a prominent position in the city, since Winchester was the capital of ancient Wessex, which covered much of present day Hampshire.

The Plague Obelisk

Plague has been a feature of life in Winchester, as it has in most other towns in England. The Black Death swept through medieval Europe and reached this

Elizabeth II Court, the headquarters of Hampshire County Council.

The Hampshire hog, a statue by David Kemp.

The Plague Obelisk.

the disease apparent at points in history between the two major outbreaks, most notably in 1379, as it had not entirely left England when it at last subsided in 1350. However, Winchester reeled under the seventeenth-century onslaught. The commemorative obelisk (dated 1754 but actually a replacement dating from 1821) is situated on an island just beyond the junction of Romsey Road, Upper High Street and High Street. It commemorates the Society of Natives founded in 1669 to help those who suffered from the horrific flea-born disease. The victims were so numerous that they were buried in communal graves in the area near St Catherine's Hill still known as Plague Pits.

The West Gate

The West Gate, at the top of the High Street, was a defensive feature of the medieval city of Winchester; it comprised of gates, the city wall and the castle. The flood plain and River Itchen provided a natural defence to the east, but the west was surrounded by hills. It had had strategic importance for centuries and was well defended by its Roman settlers, who built a ditch and bank to the east of the city in about AD 70. The first West Gate was made of timber and, two hundred or so years later, the fortifications had been strengthened to include walls made of masonry.

Over the centuries the West Gate has been rebuilt in stone, altered and repaired. The main core was built in the eleventh century, but it was substantially rebuilt in 1240 and the plaque set into the wall tells us that the building dates from the thirteenth-century rebuild. The west wall we

country in 1348. It is estimated that about 40 per cent of the English population was wiped out in just two years; this included huge numbers of priests and monks. It is no coincidence that William of Wykeham started Winchester College and founded New College, in Oxford. He wanted to both help poor scholars and ensure that there was a steady stream of students being prepared for the Church, to replace those lost.

In 1665, and again in 1666, plague hit Winchester. There had been pockets of

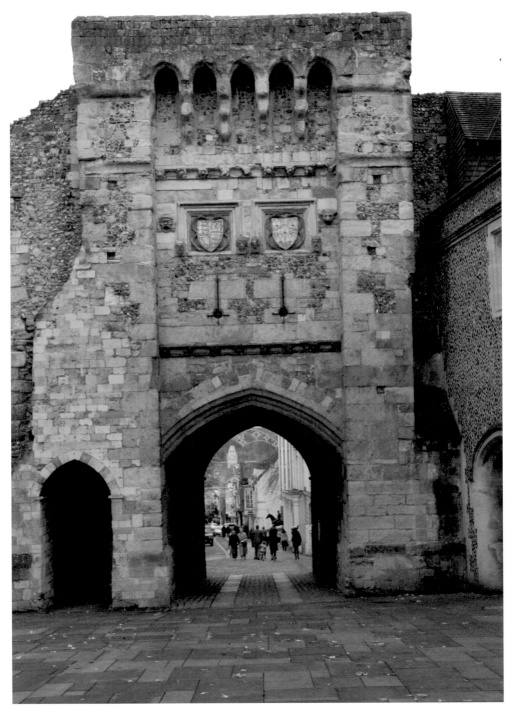

The West Gate, looking down towards High Street.

see today is the result of a fourteenth-century reconstruction, undertaken because of fears of French invasion at that time. The West Gate is now the only surviving defensive gate to Winchester, having survived the ravages of the eighteenth century (the Upper Chamber was let to an influential wine merchant, John Gauntlett). Of the five original gates, the King's Gate is the only other survivor. The West Gate is open to the public and offers a fascinating insight into the defence strategies of nearly a thousand years ago.

The gates were usually associated with churches. The Church of St Mary, outside West Gate, otherwise known (somewhat prosaically) as St Mary in the Ditch, was built in the twelfth century and was in use until the fifteenth century. It looked after the spiritual needs of the local population; there were several houses in the suburb just outside the gate, as well as travellers coming through the gate from the west. The colloquial name is taken from the defensive ditch, about 40m wide and as deep as 12m, which was dug in front of the gap, and over which visitors into the city had to cross.

The wide central arch dominates the ground floor; traffic entered and left the city through this opening until as recently as 1959. Pedestrians diced with the risk of death by being driven over in a cart or carriage until 1791, when the pedestrian opening was made. The opening is part of the original two-storey Porter's Lodge; some remains of this lodge can still be seen. The porter was an important human element of the West Gate. It was he who closed the gates when the curfew bell was rung at eight o'clock in the evening, and who opened the gates again in the morn-

ing. It was his job also to collect tolls and duties on incoming produce. Additionally, the porter was responsible for the lock-up and, later, the prison inside the West Gate. In 1890, a new pedestrian way though the south side of the West Gate was made.

The original entrance door to the stairs inside is now blocked up, but can be viewed on the south side of the passage. Access upstairs is now by a later door in the south wall. The passage originally had huge wooden gates attached at either end, the hinges of which are still visible today. Above the archway are grotesque heads with mouths open wide; they are thought to have been used for the chains of the drawbridge across the city ditch outside the gate. Invaders hoping to enter Winchester had to be absolutely determined to get through all the obstacles but, even then, they may have fallen foul of the onslaught from above. Over the arch are two slits, shaped like the mercury holders in thermometers. These were for hand-held canons and are examples of very old gun ports. Above these is the machicolation (the projecting parapet), which was very useful for throwing things onto an enemy from. Inside the public access door is a small room that was used as the lock-up for drunks or vagrants until 1760.

Upstairs, the Upper Chamber is well worth a peep; history bleeds from every stone. A useful display, part of the Westgate Museum, helps the visitor see all there is to look at here. The portcullis arch (the groove in which the portcullis rested when not lowered) is here, together with the slim slit in the floor it would have travelled through, and the heavy bars the portcullis hung from. The windows contain fifteenth- and sixteenth-century painted glass and the oldest

representation of Winchester's coat of arms. The fine painted ceiling dates from 1554.

The fireplace is Tudor and contains items of interest. The two firedogs, which held logs waiting to be put on the fire, are on either side of the hearth and date from 1458. They are not original to the building but come from Tichborne Manor House, a few miles outside Winchester. The fire-back dates from the seventeenth century and was essential in radiating heat away from the wall behind it; this came from Cheriton Manor. The giant cauldron was used for boiling, by suspending bags around the inside of the bowl, for baking and as a roasting oven. It could be suspended over the heat or stood on the trivet, on the heat. The three movement chimney crane (the large metal contraption to the right in the photograph below), was used to move pots either on to the trivet or, by swinging them out, away from the heat. This was a useful piece of equipment when utilising heavy cauldrons the size of the one in the photo-graph, and it came with a handy adjustable attachment for a candle.

The Upper Chamber of the West Gate was a debtor's prison for many years. There is graffiti notched into the soft stone of the walls here, some of which, in the portcullis arch, dates back as far as 1597. The West Gate was later used as a clubroom for the Plume of Feathers pub next door and the City Archives were housed in the building for some time too. The Plume of Feathers, on the site of an earlier building, was demolished in 1938. Since 1898 the West Gate has been a museum; visitors have a spectacular view of the city from the West Gate's roof.

The Tudor fireplace at the West Gate.

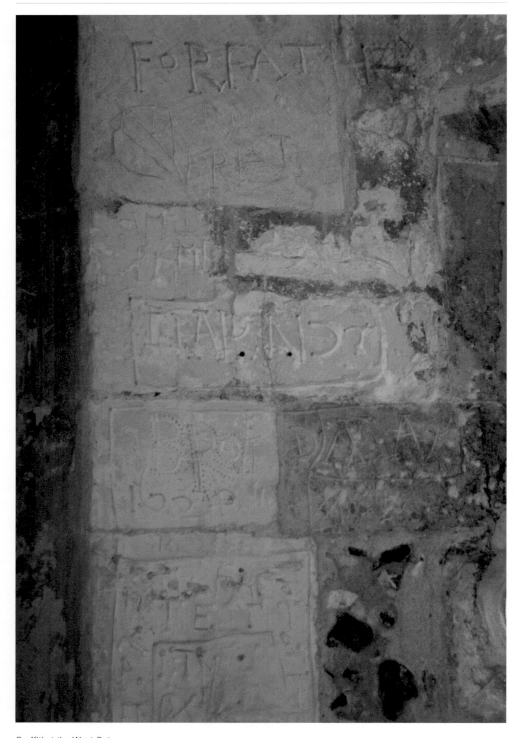

Graffiti at the West Gate.

The Jubilee Sculpture

The sculpture, commissioned by Hampshire County Council to commemorate Queen Elizabeth II's Golden Jubilee, stands on the Law Court's Terrace, not too far from the city's commemoration of Queen Victoria's Jubilee. It was completed in November 2003 and is the work of Rachel Fenner, an environmental artist. After studying at Wimbledon School of Art, Fenner had four years of post graduate study at the Royal College of Art, graduating in 1966. She has since taught sculpture at several colleges in the south of England, including Winchester School of Art. She is renowned for making many of the components of her artwork herself.

The segments around the outer circle of the Jubilee Sculpture form a round table and it is easy to see that the surroundings have had an influence on the design. Half of the outer circle uses fleur-de-lys and castles to symbolise Edward I and his queen, Eleanor of Castille, who reigned when the round table in the Great Hall was made. The other half of the outer circle symbolises religion with arches and arcades. The focal point is the throne in the centre of the flowing design, recalling Winchester's wet lands around the Cathedral; this is guarded by three figures, each representing aspects of the culture of the city. The Alfred stone recalls ancient days long past and it brings to the fore the three things the King is remembered for: the arts, religion and the defence of the realm. The Mitre stone represents religion and the status the Christian Church has held in Winchester over time. The Overflow Stone remembers Hampshire's rich resources that helped the country's early growth. These resources still flow plentifully today. The moot horns, used for centuries to summon people to a meeting, celebrate the fifty years of the Queen's reign. The mosaic pieces are all handmade, in colours influenced by medieval manuscripts.

Winchester Castle, the Great Hall, the Law Courts and the Military

The castle was built on high ground, giving a commanding view of the city. In the twenty-first century, we can only wonder at what it was like, with clues from archaeological remains, apart from the splendid Great Hall, which has survived and hints at the richness of the rest of the castle.

The area was the site of Roman defences and William the Conqueror started the building of the castle in 1067. There was a palace chapel too, possibly built by Anglo-Saxon builders; the surviving quoins, which came into use in 1072, suggest this origin. Archaeological evidence shows there was an earth motte, and then a stone keep, on the site in the twelfth century.

In front of the Great Hall stand the excavations of the old castle. These are the northern end of the original building, the Round Tower and the sally-port passages. The sally ports were in the basement and were heavily defended. They were the back entrances, which allowed defenders to go out – sally forth – to harass the enemy, attend the wounded or pick up the dead. They were large enough to accommodate the width of a horse and its rider. The excavations give a fascinating insight into the size and strength of the Norman castle, which extended past the Great Hall as far as St James' Lane, covering a four-acre site.

The castle was originally built as a fortress and held the treasury and the exchequer. It was an administrative centre but was not

immediately a residence. It was not until later, when Henry I took control of the treasury at the castle (and thus took the throne from his absent elder brother after the untimely death of William Rufus in the New Forest), that the castle became a royal home. During Henry II's reign the castle's function changed, as the treasury and administration were transferred to London. The castle became, simply, a royal residence.

Henry III, known as Henry of Winchester, was born in Winchester Castle on 1 October 1207. In 1216, during the turbulent times at the end of King John's reign, France was vying for the English throne and so the French besieged the castle. John died in October of that year and nine-year-old Henry was pronounced king. The castle was rebuilt the following year when it was recaptured. Over the next thirty-six years the castle was significantly expanded, under the direction of Peter des Roches, Bishop of Winchester and Henry's protector while he was still a minor. The Round Tower was built near the West Gate and the royal apartments were upgraded. The Great Hall was begun in 1222 and took fourteen years to complete, thus leaving a lasting reminder of Henry's attachment to the city. The pillars were made of stone from the Isle of Purbeck and it had plate-tracery windows and pointed arches. Only the finest materials were used and the colours were brilliant. There was a wheel of fortune painted on the wall where the round table now stands and the King and Queen's seating was elaborately decorated. In short, Henry wanted a sophisticated and elegant building, which would be the heart of the castle; that is exactly what he got.

At Easter 1302 a fire took hold of the royal apartments while Edward I (1239–1307), known as Edward Longshanks, and his queen, Margaret of France, were in residence. Indeed, they were lucky to escape and the fire effectively ended the royal residence there. In future, royalty stayed at Wolvesey Castle when in Winchester. Elizabeth I gave the castle to the city and by 1642 it was privately owned by a Parliamentarian citizen. In 1651, during the Commonwealth, the castle's destruction was ordered, but full demolition was abandoned because of the strength of the defences. The Great Hall escaped unscathed.

The entrance to the Great Hall, which is open to the public, is via a Victorian door dating from 1845. The hall was used for Parliaments between 1330 and 1449. The east wall makes interesting reading as it is decorated with a list, made in 1847, of all the knights of the shire who represented Winchester at Parliament between 1283 and 1868. Set into this 10ft-thick wall is a pair of impressive stainless steel gates that were made as a gift from the people of Hampshire, to commemorate the wedding of Prince Charles and Lady Diana Spencer, in 1981. They were made by Anthony Robinson and are the first of their kind in the world.

The main windows date from the fourteenth century, although the stain glass within them is Victorian (1875–80). The glass shows the coats of arms of those great and good in Hampshire and the portraits are those of kings who have special relevance to Hampshire.

In 1603 it was in the Great Hall that Sir Walter Raleigh was brought to trial for treason and then condemned to death. This was a sentence that was not carried out until 29 October 1618, when he was beheaded in Whitehall.

The excavations of Winchester Castle.

The Great Hall has held many a murder trial. Jim Brown, in his book *Southampton Murder Victims* (2010), describes the scene when a trial was taking place. The west wall, with its round table dominating the proceedings, had a long raised bench erected below the table for the Assize judge. Opposite him sat the prosecuting and defending counsellors; the prisoner stood under guard in a raised dock at the back, towards the east wall. The witness box was at the front, towards the left, near the judge. Interestingly, an IRA bomb trial was also held in the Great Hall in 1973.

The Great Hall of Winchester Castle was built on a plateau on St Paul's Hill, the highest point in the city. The land falls towards the city and it was here, on huge foundations on the steep slope, that Victorian builders, under the direction of Sir Melville Portal, erected the law courts in 1873. They were designed by T.H. Wyatt, who used the opportunity to restore the adjoining Great Hall. Sadly, the foundations were not up to the task of holding such a weight; they began to sink almost immediately and cracks soon appeared in the building. The Great Hall had to be brought into use again and so it was partitioned off as makeshift courts. Lord Hailsham, Lord High Chancellor, opened the current Crown and Magistrates' courts in the same building, on 22 February 1974. They were built on the site after the Victorian building was demolished in 1937.

The regal Queen Victoria statue in bronze, now sitting in the shady north-west corner of the Great Hall, was first unveiled

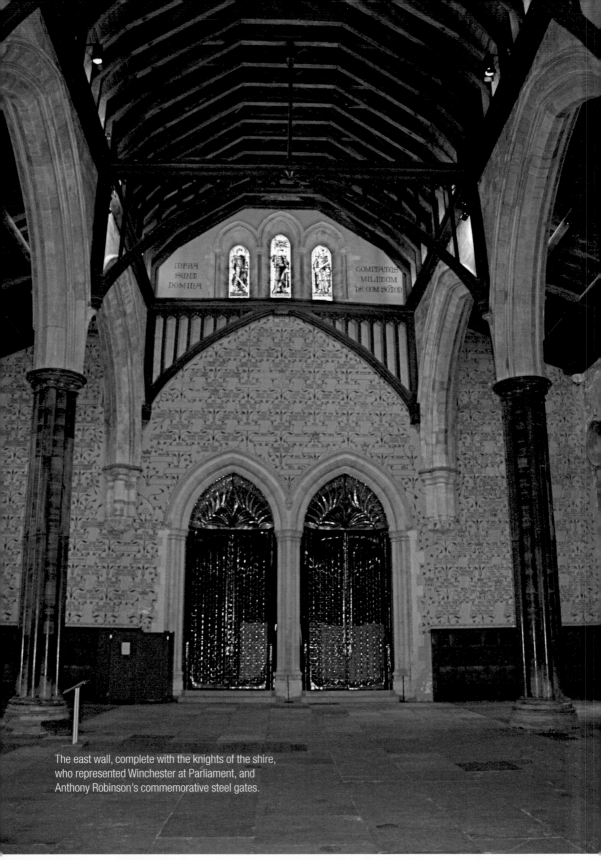

The east wall, complete with the knights of the shire, who represented Winchester at Parliament, and Anthony Robinson's commemorative steel gates.

The Victorian stained glass in the Great Hall.

in the Castle Yard, in 1890. W. Ingham Whitaker, the High Sheriff of Hampshire, had commissioned it in 1887, to celebrate the Queen's Golden Jubilee. This magnificent statue, stately in every way, was originally going to be made of marble, but was cast in bronze so that it could weather the elements. It was moved to the Abbey Gardens in 1893 and stayed there until 1910. It suffered vandalism and had to be repaired by its sculptor, Sir Alfred Gilbert RA (1874–1934), the artist behind the statue of Eros in Piccadilly Circus, in London. Gilbert had to build a new and more robust base to hold the statue.

This statue was Gilbert's first great public work and he asked his mother to model for it. In 1910 it was felt that the statue of King Alfred, erected in 1901 just a short distance away, overshadowed the mighty Queen. The luckless statue

was once again shifted, back to the Great Hall, where she was positioned inside, directly beneath the round table high on the west wall and in 1912 was unveiled once again, this time by Princess Henry of Battenberg. The statue did not fare well in all this travelling and the metal crown had to be reconstructed before it could be unveiled.

The statue is remarkable for its detail; it has allegorical figures decorating the substantial throne, an elaborate orb with a flying victory, a bejewelled sceptre and a golden openwork crown suspended above the Queen's head. The Queen is stately in her flowing robes and sits surveying the Great Hall in the gloom of the corner she now occupies.

High on the wall of the Great Hall of Winchester Castle, silently surveying all who enter, is the magnificent oak table, 18ft

The Round Table in the Great
Hall at Winchester Castle.

in diameter and weighing 1200lbs, which is said to be King Arthur's Round Table.

Thomas Malory (1405–1471), the colourful author of *Morte D'Arthur*, was convinced that Winchester Castle was Camelot and wrote twenty-nine books of his adventures; it seems fitting that King Arthur Pendragon's Round Table is found here in the Great Hall.

The table was made between 1250 and 1280 and was repainted for the first time over the period 1516–1522. The central Tudor Rose is a reminder to all in the land that the Tudor dynasty came from the Pendragon line. The names of the Knights of the Round Table feature on the edge of the table, which originally had legs to support it when on the ground.

The origins of Arthur's story are elusive. He could be the brave Christian knight mentioned in the seventh-century Welsh poem, 'Godolin', by Aneirin Gwawdrydd. His victorious battles against the Saxon invaders are listed by Nennius in the eighth century. In the twelfth century William of Malmesbury took Arthur into the realm of myth and legend by claiming, in his *History of the Kings of England*, that his tomb is unknown and that he will return. It is through the work of Geoffrey of Monmouth that we learn Arthur was the son of Uther Pendragon and was born in Tintagel Castle, in Cornwall. He was crowned King at the age of fifteen at Silchester. Geoffrey also brings Morgan Le Fey and Merlin into the story for the first time. He tells us that Arthur and Modred, Arthur's nephew, battled each other and that Arthur was mortally wounded; he does not say that Arthur actually died, thus bringing his account in line with that of William of Malmesbury.

The first mention of the Round Table is in *Roman de Brut*, written by Robert Wace in 1155. He explains that the table was round so that all of Arthur's knights would feel equal. Malory goes further, by adding the detail that the table was a gift from Leodegrance, Guinevere's father, on her marriage to Arthur. Whatever the truth about Arthur, the Round Table at Winchester is a spectacular monument to an enduring legend.

The doorway opposite the main entrance leads to the pretty Queen Eleanor's Garden. The Hampshire Gardens Trust restored this in the style of a medieval garden; Sylvia Landsberg and John Harvey designed it and the Queen Mother opened it in 1986. All royal residences would have had gardens; this one was designed according to

The falcon in Queen Eleanor's Garden.

records kept of such gardens. It is named after the two queens from the time when the castle was residential – Henry III's consort, Eleanor of Provence, and Edward I's first wife, Eleanor of Castille, who died in 1290. The garden is full of old-fashioned flowers, such as foxgloves and honeysuckle, and there is a very pleasant vine-covered arbour. These flowers would have been grown in the thirteenth century.

In the Middle Ages flowers and plants had symbolic meanings. Green grass, ivy, bay, holly and other evergreens represented faithfulness, whereas religion was symbolised by such plants as the rose, columbine and the lily. The Queen's herber (the screened sitting area) is planted with the white roses of the House of Lancaster and red roses of the House of York. The pool and the fountain were other typical features of the period. The wooden falcon in Winchester Cathedral inspired the falcon fountain here, which is directly opposite the doorway from the Great Hall.

Military Winchester

Behind the garden stretches the Peninsula Barracks. This land was originally part of the castle site. In 1682 Charles II commissioned Sir Christopher Wren to build a palace on the land; one inspired by the palace at Versailles. It was to be called the King's House and Charles was impatient for his new country seat. By the time of Charles' early death in 1685, when he was fifty-five, £45,000 had been spent and the shell of the magnificent house was built. Wren had envisioned a main house with a central portico, with flanking wings around three sides of a main courtyard. It

was supposed to have 120 rooms, including state apartments for the royal household and the King's mistress. The King would have been able to see the fleet at Spithead from the domed cupola erected above a fine marble-columned portico. The whole grounds would have had a circumference of ten miles. When the King died, the work stopped and, as Morris and Hoverd (1994) noted, the house (big enough to accommodate the whole court for the summer), 'was home to two watchmen and a dog.'

During the French Revolution, 600 priests sought refuge in the King's House. Britain was once more at war with the French between 1793 and 1818 and the palace was converted into a barracks in 1796. It continued as such until it suffered a fire in 1894 and had to be demolished. The Peninsula Barracks were erected in place of the old palace between 1899 and 1904, using some of the recycled original portico, the columns and masonry, in the new building.

Nowadays it is no longer a military establishment, but a site for housing and military museums. A wander around this huge area, much of which was designed by Edward Ingress Bell (1837–1914) and Major F.S. Leslie, shows much that is of interest.

It is best to start a walk about the Peninsula Barracks from Romsey Road. Winchester's military visitor centre is clearly visible on Queen's Court, a short walk up the hill from the West Gate. It is the former guardhouse, which was inspired by Sandhurst Royal Military Academy. Inside, in the Adjutant General's Corps Museum, is an interesting display about the soldier as an individual: how he was treated, his pay and education, and what happened to him if he stepped out of line. The exhibit is quite a

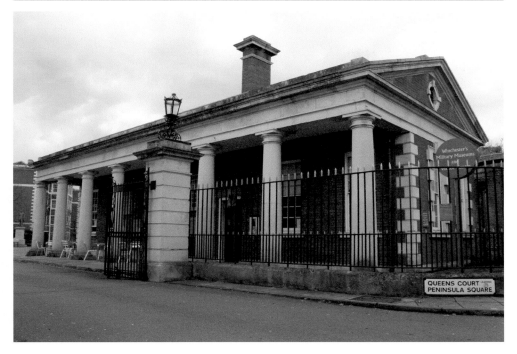

The old guardhouse, now the visitor centre at the Peninsula Barracks.

The Rifles Museum at the Peninsula Barracks.

graphic one, showing the innocent looking 'cat o'nine tails', which could be used up to 1,200 times on a man's back, with horrifying consequences. The exhibition also pays tribute to women in the army and shows how their status transformed; originally they were thought of as a nuisance and barely tolerated, but in time they were considered an integral part of the modern army. The display also provides a history of the military police. The museum is free to enter and gives a good general overview of many aspects of everyday army life.

Outside, opposite the guardhouse, and running parallel with Romsey Road, is the old infectious diseases hospital; it is now residential housing. This was built in 1856, with advice from Florence Nightingale. Moving along Queen's Court, away from the guardhouse, the old militia stores are now used as military museums.

The Light Infantry and Royal Green Jackets (Rifles) Museum opened in 1989 and focuses on the regiment's campaign for peace, its approach to soldiering and the courage of its members; fifty-nine members of the Rifles have won Victoria Crosses. The name of the barracks is taken from the Royal Green Jackets' Maltese Cross cap badge, which has the Peninsula battle honour across the top. This is prominently displayed outside the museum building. The Royal Green Jackets were amalgamated with the Devonshire and Dorset Light Infantry, the Light Infantry and the Royal Gloucestershire, Berkshire and Wiltshire Light Infantry, in 2007. They are now known as The Rifles – The British Army's Rifle Regiment.

In the Queen's Court, a late twentieth century addition to the barracks site, stands the impressive statue of old Wykamist John

Old Wykamist John Colborne (Field Marshall Lord Seaton).

Colborne, Field Marshall Lord Seaton (1778–1863), who was born in Lyndhurst. This statue, originally sited in Seaton Barracks in Devon, was the work of sculptor George Gammon Adams (1821–1898), a renowned producer of public statuary and the artist selected to take the Duke of Wellington's death mask in 1852. Queen Victoria purchased the subsequent bust.

Peninsula Square is impressive on first sight. The parade ground has gone and has been replaced with formal gardens, reminiscent in style of the seventeenth century, with water features and raised parterres linked with gravel walks. The gardens date from the end of the twentieth century. The military moved out of the fifteen-acre barracks in 1994 and, apart from the buildings set aside for military museums, the site was re-invented into housing by Winchester-based architect Huw Thomas, between

King's House and gardens at the Peninsula Barracks.

1995–98. Today, two-bedroom houses on the site command million-pound price tags.

The old King's House was rebuilt after the fire using salvaged materials where possible and it was imaginatively named Long Block by the army. It makes an attractive focal point on the west of the square. It is four storeys high and has twenty-five bays. Corinthian columns, pilasters, giant entablature and the pediment containing the royal coat of arms (recycled from the King's House), all combine to make this building instantly recognisable.

Also on the site are the Short Block (Clock House) to the north and the Junior Rank's Club, known as Wren House, to the east, which was later the Sergeants' Mess. The former gymnasium and the weapons instruction shed have also been transformed and utilised. The Lower Barracks are now 1990s-built housing.

The other museums on the site are the Ghurkha Museum, which tells the history of the service of the men of Nepal to the British Army – service which stretches back to 1815 – and the Museum of the King's Royal Hussars, which charts the story of how the traditional horse and sabre soldiers of yesterday have developed into the armoured regiment of today.

No mention of military Winchester would be complete without a look at the Royal Hampshire Regiment. Born of the 1881 amalgamation of the 37th Foot (North Hampshire), raised in 1702, and the 67th Foot (South Hampshire), raised in 1758, the Tigers (as they were affectionately known following the 67th Foot's time in India) were a feature of Hampshire life, until 1992. It was in Winchester that the Tigers were based, as the city was the Hampshire Regiment Depot.

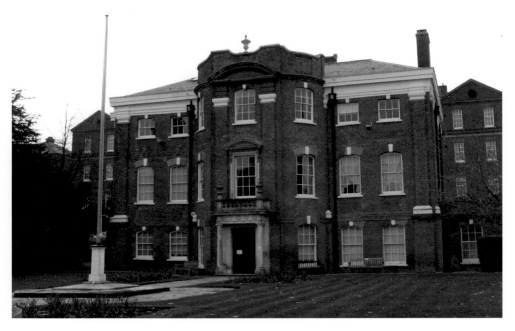

Serle's House, home of the Lord Lieutenant of Hampshire and the Royal Hampshire Regiment Museum.

In the First World War, thirty-six battalions were raised and sixteen of them served overseas, in most of the front lines. Between the wars the Tigers were all over the world, in places as diverse as the north-west frontier in India, Ireland, Russia and Germany. During the Second World War, they were on the beach at Dunkirk, and involved in the D-Day landings in Normandy. They fought in Palestine, Malta, Sicily, Italy, Greece, Holland and Germany.

After the war, the regiment began to decrease in size, but still saw active service in such places as Malaya, the Caribbean and the Falklands. In 1992, the Royal Hampshire Regiment was amalgamated into the Princess of Wales' Royal Regiment, known as the Tigers. It is still on active service, as evidenced by the Victoria Cross awarded to Lance Corporal Johnson Beharry in 2004, for his bravery in Iraq.

Serle's House on Southgate Street, reachable via a footpath from Peninsula Square, is the home of the Offices of the Lord Lieutenant of Hampshire. Since 2004 it has also housed the Royal Hampshire Regiment Museum and archive. The house, which is Grade II listed, dates from 1730 and is a fine baroque building, thought to be designed by Thomas Archer (1668–1743) for recusant William Sheldon (listed in the *Records of the English Catholics of 1715* by John Orlebar Payne). Peter Serle, a captain in the South Hampshire Militia, whose father James bought the house in 1781, sold it to the government in 1796; it has been in government service ever since.

The Backbone

Dame Elisabeth Frink in Winchester

ELISABETH FRINK was born in 1930 in Thurlow, Suffolk. She studied at the Guildford and Chelsea Schools of Art and taught at both the Chelsea and St Martin's Schools of Art before becoming a visiting lecturer at the Royal College of Art, between 1965 and 1967. She was a print maker and sculptor, part of the post-war Geometry of Fear school, which included names such as Reg Butler and Eduardo Paolzzi. Her 'Horse and Rider' dates from 1975 and sits looking up the High Street, towards the West Gate.

She was interested in men, dogs, horses and birds as subjects for her sculptures and she was prolific in her modelling, casting them in plaster and then carving the plaster to make the surface tougher for casting in bronze. Her figures and horses have a simplicity of form that stops visitors and draws the eye, as can be seen in the dignified rider and his mount in Winchester. It is very tempting to wonder about this life-size statue: where has the pair come from? Are they thinking of going up the High Street to the West Gate? Are they aware of the people around them in the street?

Elisabeth Frink received many honours in her lifetime. She received honorary doctorates from six universities, including Cambridge in 1988 and Oxford in 1989. In 1969 she was awarded the CBE and was made Dame of the British Empire in 1982. She died of oesophageal cancer in 1993, at Blandford Forum, Dorset, just a week after her final work, a statue called 'Risen Christ' for Liverpool Cathedral, was unveiled.

Staple Gardens

Staple Gardens has had some highs and lows in its long life. It was originally the road leading to the Winchester Staple, which was set up following the 1354 Statute of Staples, which fixed fifteen towns as staple (settled) market towns. This was a town that was restricted in what it could sell to foreign traders. Traders from France and Flanders came to the Winchester Staple to trade wool. Other Staple towns were Bristol, Canterbury, Carmathen, Chichester, Cork, Drogheda,

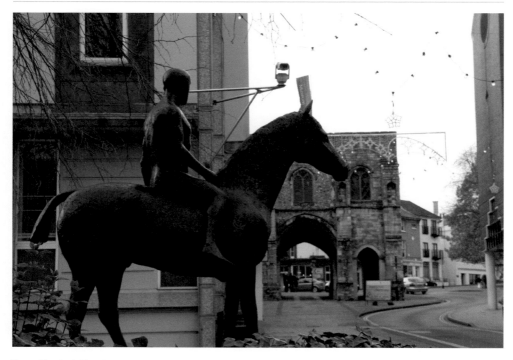

Dame Elisabeth Frink's horse and rider gaze up the High Street towards the West Gate.

The cinema in Southgate Street, the former chapel and the schoolhouse at the Peninsula Barracks.

Dublin, Exeter, Lincoln, London, Newcastle, Norwich, Waterford and York. The area fell out of use following the relaxation of wool trading regulations in the fourteenth century. The area was later used as the city dump.

Mottisfont Court

This somewhat stark building, built in 1990–91 by Sir Colin Stansfield-Smith, stands just along from the Elizabeth II Court and the Elizabeth Frink statue. It is the home of Winchester's trading standards department.

Southgate Street

Southgate Street shows the grandeur of former days in its large houses and endearingly uneven rooflines. The Hotel Du Vin dates from 1715 and has an original Doric porch. On the wall next to the hotel is an old War Department sign, cut into the stone; it is a reminder of the military, which was all around this area.

On the same side of the road as the Hotel Du Vin is Seales House and along from that is one of the Old Barracks' guard houses, on the corner of Archery Lane. Further along is the Screen cinema, housed in the Old Barracks' chapel and schoolroom. This dates from 1851; it was converted into a cinema in 1996. On the other side of the road is The Green Man public house, another of Thomas Stopher's buildings, and also some imposing Victorian terraces.

At the point where Southgate Street becomes St Cross Road is the site of the old South Gate, which was first a Roman gate and then a medieval one. It was demolished in 1771.

Down the Backbone of the City

For nearly 2,000 years the High Street has been the hub of the city. The Romans laid it out in the first century. A stroll along the road is full of history waiting to be noticed. The street was pedestrianised between Market Street and St Thomas' Street in 1974. It was paved with flagstones in 1976.

Zizzi

This restaurant is housed in the stucco-fronted property that was home to the Jacob and Johnson building, the abode (from 1813 until 2004) of the *Hampshire Chronicle*, which started life in 1788. The newspaper now has new premises opposite the Brooks shopping centre, on the corner of Upper Brook Street and St George's Street.

God Begot

The area known as God Begot or Godbegeaton (good bargain) was bequeathed to the Priory of St Swithun by Queen Emma (*c.* 988–1052), second wife of King Ethelred the Unready, and then King Cnut. In 1291, it was agreed that the residents of God Begot would not be able to claim rights as a citizen of the city and, if they wanted the freedom of Winchester, they would have to pay ten marks for the privilege. Further, all trade between the inhabitants of God Begot and city dwellers was forbidden. Any citizen risked excommunication if he entered God Begot to attack or detain its residents. This uneasy, dual state of affairs existed until the Dissolution, but the Church retained own-

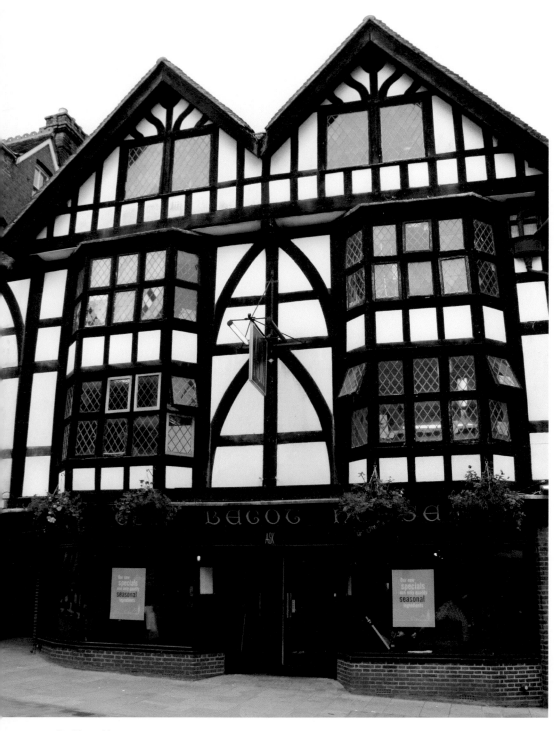

God Begot House.

ership of the area until 1866, when it was sold to Mr James Pamplin, a stationer. On his death, his daughter Edith carried on the business, before turning the building into a private hotel.

God Begot House has been extensively renovated, but is still an impressive building, which retains some of its original timberwork in the interior. Edith Pamplin added the timber framing to the front in 1908, which was paid for by her friend, Pierpont Morgan, a financier from America. During the First World War, Miss Pamplin gave an annual Christmas party at the house for the Cathedral choristers and the girls from Winchester High School, now known as St Swithun's. Miss Pamplin died in 1937. Originally, the house was part of a terrace of similar buildings.

Beside the restaurant that is now God Begot House, is an alleyway called Cross Keys Passage. This gives an idea of how narrow the passageways were in the medieval city; note the jutting first floor to the timbered building, which hangs over the alley.

Ye Dolphin Inn

This former public house, now a shop, is reputedly haunted. Several sightings of a decapitated head have been reported here. Mr R. Moss, a Winchester brewer who rebuilt the upper storeys in 1883, owned the building. The twin dolphins over the doorway are replicas of the originals, said to have been knocked down by the vibrations of lorries thundering past before the road was closed to traffic.

The Old Guildhall

The site that is now Lloyds bank was once Winchester's Hall of Court. It was here that the Mayor of Winchester and the two bailiffs heard cases in the Court of Record. The earliest record of the Hall on this site dates from the thirteenth century, but the current building dates from 1711–1713, when it had an open arcade on the ground floor. The curfew bell is rung from the boarded turret on the top of the building every evening at 8 p.m. This has been a tradition since the eleventh century.

The statue of Queen Anne was a gift from George Bridges MP and the clock, recently sent for repair and re-gilding, was originally given by Lord William Paulet MP in 1714; he did not want to be outdone by his opposite number. The present clock is a reproduction made by a local clockmaker, Edwin Laverty. It is said to be the first of its kind in the south of England to be illuminated by gas.

The façade was remodeled in 1915, when it became a bank, and it has been extended into what was 48 High Street.

Boots the Chemist

Boots was purchased in 1903 for £4,000 and as much again was spent on renovating it. It then opened as Boots Cash Chemist. The mock Tudor frontage has statues of four of Winchester's favourite bishops in niches on the first floor: Aetholwold (963), Walkelin (1070), Wykeham (1367) and Fox (1500).

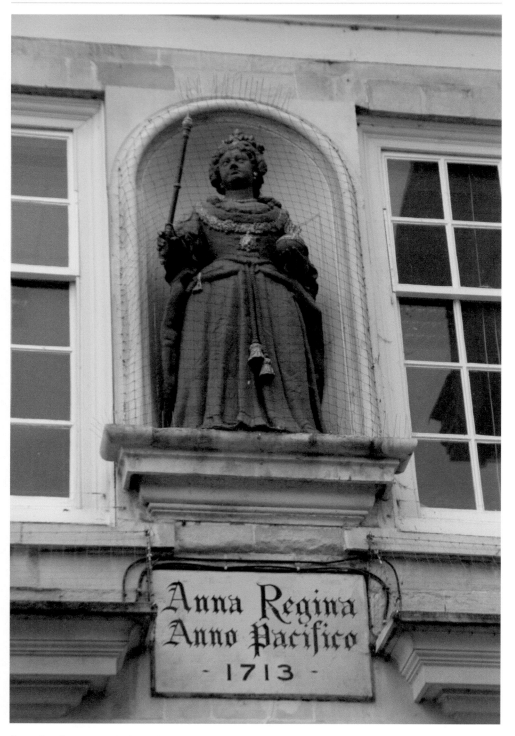

Queen Anne's statue on the front of the old Guildhall.

Number 47

Grade II listed 47 High Street, currently JD Sports, was the scene of an address by the Duke of Wellington, when it was a nineteenth-century coaching inn. The Duke took political office after his military career ended, and addressed a crowd from the first-floor window.

Parchment Street Junction

On the corner of High Street and Parchment Street stands WH Smith. The Masonic Hall used to stand at the far end of Parchment Street and the Awdry restaurant dominated the middle of the street; it closed in 1966. The hospital used to stand in this street too. Parchment Street was partially closed to traffic when High Street was pedestrianised in 1974.

The Pentice

The medieval, colonnaded walkway on the south side of the High Street is on part of the site of an old Norman palace. Indeed, it has been suggested that 28 and 29 High Street were the palace kitchen and the wool shed respectively.

Over time the shops crowding the High Street needed to expand, but could not do so for fear of encroaching on the road. The solution was to build outwards some 3.8m from the first floor and to support the new galleries with sturdy pillars; the result is the Pentice. However, there is evidence to suggest that the pillars were not originally there to support the overhanging structures.

The site was originally a line of shanties, but 39–40 High Street was also the 'King's Mint' after the palace was destroyed. A fire in 1180–81 burnt the mint down, along with several other properties. Minting ceased in the city in about 1217. Henry III leased the site to the city as a drapery, at a rent of £6 per annum; the area became known as Drapery Row or, alternatively, the Piazza.

The Buttercross

The name derives from the nineteenth century, when there was a dairy market in the area, but the 43ft-tall High Cross is fifteenth century.

The earliest references to the cross were in the fourteenth century when one Walter de la Cross was a local tenant. In the Middle Ages, the cross was flanked by

The Pentice on Winchester's High Street.

The Buttercross.

public houses called Hevene and Helle. In 1770, there was nearly a riot when local people heard that the cross was going to be sold as a garden ornament to a local land-owner. It was in danger of demolition in the nineteenth century, in a bid to improve the city's roads, but local opposition to its destruction led, in 1865, to architect Gilbert Scott rebuilding the upper sections of the monument and restoring it to its former, eye-catching glory. Only the statue of St John, on the south side, is medieval. The Buttercross was renovated once again in 1992.

The building in which Pasty Pesto stands, behind the cross, is dated to 1540 and was a print works for many years. The building to the left of the cross was a sweet shop for more than fifty years.

The Morris Men

If you are lucky, when you wander about Winchester's streets you might find yourself watching the dancers from the Winchester Morris Side. This owes its existence, as do many of the Morris Sides in England, to Cecil Sharpe (1859–1924), who was intrigued by the dances and started to note them down.

Morris dancing was popular in Tudor times and has always been popular with the masses in towns and villages. Roy Christian, in *The Country Life Book of Old English Customs*, speculates that the origins of Morris dancing is a 'survival from the primitive past connected with food supply and the fertility of the soil, which gradu-ally lost its original point in Christian times to become just another form of communal entertainment.'

The men's Morris clubs belong to the Morris Ring, the association that keeps Morris Sides up to standard; it was formed in 1934. The Federation and the Open are two other Morris associations, one for ladies and the other for both sexes.

Lionel Bacon, Winchester's medi-cal officer, started the Winchester Side in 1953, shortly before the 1960s Great Revival, when there was a surge of inter-est in jazz and folk music. The dances that the Winchester Morris Men entertain their audiences with come from the original Cotswolds villages that Sharp visited. Sharp had formed his own demonstration team and this showed the farm labourers, brick layers and other artisans, who chiefly made up those who danced, what the structure and patterns of the dances were.

The Winchester Morris Men, though few in number, are still to be found at points around the city and beyond. According to their website, they were scheduled to dance on more than forty occasions in 2010, often at more than one venue in a day. This included dancing at the Buttercross and then on to Winchester Cathedral ice-rink on Boxing Day.

Number 113

The White Horse Inn, at no. 113, was a painted, brick-fronted building in 1879, with a smart lantern protruding over the front door and a large, rounded nameplate dominating the middle of the first-floor frontage. Today the building is of flint and brick, having been rebuilt just before the turn of the twentieth century. The name is now proudly displayed in the façade, but the White Horse Inn lost its license in 1936.

Winchester's May Fest

Keeping tradition and history alive is what the Winchester May Fest is all about. Every May the city is buzzing with events taking place in concert halls, local pubs and all over the streets. Traditional and contemporary music, dance and children's events, together with markets and workshops, brighten up the city and bring the past back to life. Previous performers have included the Winchester Community Choir, the Askew Sisters and Craig; Morgan; Robson singing traditional Hampshire folk songs.

The Hat Fair

Visit Winchester during the Hat Fair and you are in for a treat! This is a gathering of street performers; you never know quite what you will see when you turn the corner, particularly if you walk along High Street.

The Hat Fair started in 1974 as a buskers' festival, when performers passed around a hat for collections at the end of their performances. The name stuck and today the event has gone from strength to strength, with performers still sending their hats around for donations.

Over time the event has developed to include picnics, markets, community projects, music and large-scale spectaculars. At its core though, are the small entertainers, including musicians, acrobats and comedians.

The Brooks Centre

Dominating the north side of St George's Street, the Brooks Centre, designed by BDP Architects, was completed in 1991. St George's Street was a narrow Saxon street, lined with traders' warehouses, which had to be widened to accommodate the new shopping centre.

Before the centre was built, there was an archeological excavation on the site; the results of this are now on display in a small museum in the centre's basement. These comprise Roman and medieval finds from the first century onwards, including the remains of a fourth-century Roman town house with its under-floor heating system, and a twelfth-century vintner's house and reproduction cellar.

The Brooks Centre features a tower on the north side with a carillon of bells, which ring on the hour. This is reminiscent of ecclesiastic buildings and the impression is reinforced by the triangular roof shapes, similar to those of the medieval churches in the city. Opposite the Brooks Centre, on Middle Brook Street, is Marks and Spencer, a landmark built in 1935.

The High Street becomes the Broadway at the bottom of the hill and it is here that the bus station is situated. The Hants & Dorset bus station was built on the site of the old Cusworth's booking office, the agents for Kingston and Modern Travel, at 160–165 High Street. The Mayor, Councillor O.J. Hodder, opened the site with a pair of golden scissors, which were adorned with a tiny Hants & Dorset bus in enamel. The date was 20 June 1935 and it was a typical English summer's day – rain was pouring. The first vehicles to enter the station were the Mayor's car, a bus and a coach.

Hants & Dorset had been using ground-floor rooms in St John's House for booking tickets for their services and a Miss Smith rented part for a refreshment hall. The new

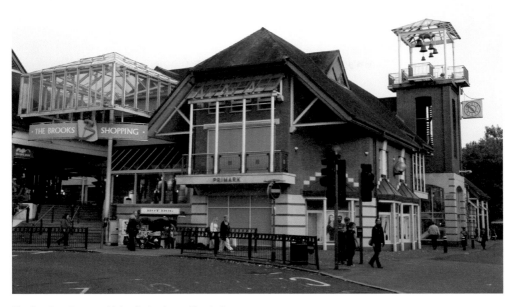

The Brookes Centre, with its distinctive carillon bells.

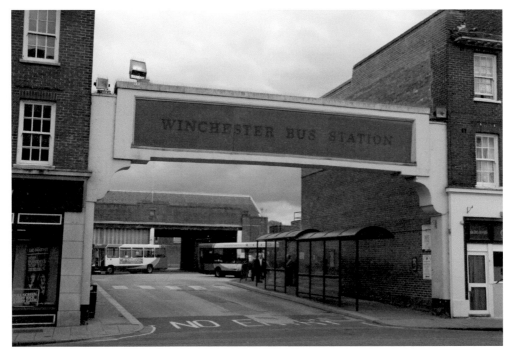

The Winchester bus station.

bus station incorporated both of these elements with its dedicated booking hall and refreshment facilities. The new station meant that all the Hants & Dorset vehicles clogging up the Broadway now had a home. With their removal, other operators, including the King Alfred Motor Services bus company, had more room on the street for their vehicles.

King Alfred Motor Services was the brainchild of Robert Chisnell, born in Winchester in 1870. He was a local businessman; he had already run a fruit and fish business with another family, the Goodenoughs. This family lent him £50 to open a tobacconists shop at 4 Bridge Street. This business expanded and a second tobacconist shop was opened in Jewry Street, managed by his brother, Charlie. Chisnell then opened a bookmaking business, to capitalise on his love of the turf. After this he opened a roller-skating rink in the old Corn Exchange and also, when his brother-in-law's marshy farm iced up one winter, he charged visitors to skate on the resulting ice rink. Robert Chisnell was a man of ideas; he had the vision to carry them through, although not all his ventures were happy ones and he narrowly escaped being declared bankrupt in 1911. At this time he trimmed down his holdings and carried on.

During the First World War he acquired a Darracq motor vehicle and used it to replace the carts he had been using for his wholesale tobacco business, when the horses were commandeered for war service. Transporting tobacco and, later, strawberries, to the railway station at Chesil, made him realise that there was a need for troop-carrying transportation. This was because another venture, the SPO, or the Sausage,

Potato and Onion, a business he had set up at 18 Bridge Street, was very popular with the soldiers coming into the city from their training camp nearby. Another such restaurant, on the corner of St Thomas Street and St Clement Street, followed it. Soon Chisnell had a fleet of vehicles carrying troops from the camp, at the top of Morn Hill, to the city and back again, at a shilling each way. Chisnell then acquired several cars to run as taxis for the officers. He was also involved in the transportation of wounded soldiers, when they were returned to Winchester on troop transport trains to Chesil station. Additionally, he ran trips to the New Forest for convalescing soldiers.

When Bridge Street was widened, Chisnell started to park his fleet on the site of the demolished nos 18 and 19. At the end of the war, he was employing two lady taxi drivers, Lillian Beckett and Mollie Hayden, the first such in Winchester.

After the war, Chisnell bought two old RAF truck chassis and converted them to charabancs. They also began operating from the Hillside Garage. The first outing was on Whit Monday, 24 May 1920, to Bournemouth and the driver was Vic Holland. It was the start of the King Alfred Motor Services company; Chisnell had the distinctive King Alfred logo, in gold, inscribed on the back of the vehicle.

The business prospered and soon King Alfred was regularly running out of the city to other places – Overton, Sutton Common, Stockbridge and Crawley. There was also a short-lived express service to London. By 1940, with Chisnell's sons now also involved in the business, the King Alfred Motor Services Company was a well-established part of life in Winchester. When Robert Chisnell died, on 5 June

1945, the business passed to his sons, known affectionately as Mr Bob and Mr Fred.

Post-war life saw increasing numbers of motorcars and this negatively affected passenger numbers for the business, and increased road congestion. The routes King Alfred operated on were consolidated at the end of the 1940s and route numbers had been introduced in the 1950s. By the 1960s though, things were looking better for the company; it weathered staff shortages and shorter working hours by cutting less profitable evening routes. However, it was increasingly noticeable that the fleet was not as immaculate as it once was. By the 1970s, staffing problems, traffic congestion, and the closure of more unprofitable services, were problems that made the viability of the company questionable. Eventually, the King Alfred Motor Company was sold to the Hants & Dorset Company. The Hillside Garage closed on 28 April 1973, bringing fifty years of transporting paying passengers to an end.

Today, the company lives on in the form of the Friends of the King Alfred Buses, organised in 1985. A Running Day is operated on 1 January every year, in which ten of the twelve buses, owned by the Friends, are run; free tickets are issued on board by a 'clippy', or bus conductor. In 2010, 20,000 passenger journeys were made on Running Day.

symmetrical new Guildhall was more than £10,000. It was inspired by the thirteenth-century Cloth Hall in Ypres and Godwin's Northampton Town Hall, built in 1861–4 (the extension for which Jeffrey was joint architect in 1889–92). After the opening ceremony, there was a celebratory luncheon hosted by the Mayor, Robert P. Forder, at the George Hotel, on the corner of High Street and Jewry Street; this was demolished in the 1950s.

The Guildhall has a clock tower and angled pavilions, which are outlined in eye-catching green slate and decorated in purple. The Guildhall, with its gothic splendour, housed the City Council, the Magistrates' Court, the City Museum, the police station and the City Fire Station. The fire engine was housed within the building, but the horses were kept some distance away, on Station Hill.

In 1876, the west wing was added. It was designed by Thomas Stopher, who has had such a lot to do with the designs of Winchester in the nineteenth century. It contained the School of Art, the library and the reading room. It sits on the end of the original building and is made of flint, with Bath stone dressings. It looks like what it is; a functional afterthought.

Inside, the King Alfred Hall features a stage extended in 1892–3 by another local designer, John Colson.

The Guildhall

The foundation stone for the new, gloriously gothic Guildhall was laid in 1871. It was opened in 1873, having been designed by Jeffrey and Skiller, the little known firm from Hastings that had won a competition to do so. The cost of building the

Abbey House

Abbey House is the official residence of the Mayor of Winchester. It owes its existence, in its present form, to William Pescod, who reconstructed it in 1751. It was purchased in 1890 by the Winchester Corporation for the sum of £5,500. The house is interest-

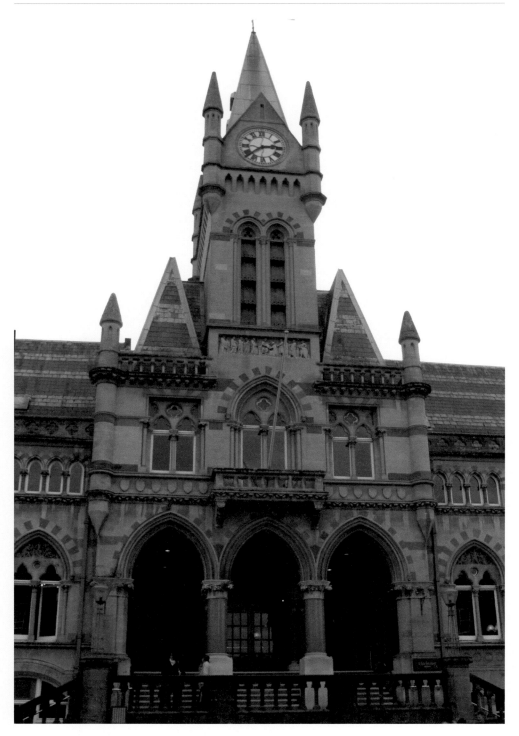

The gloriously gothic Guildhall.

The front of Abbey House, the mayor of Winchester's residence.

ing because the park-side of the building, with its red brick façade, pediment and sash windows, is definitely classical, whereas the view from the Broadway at the front is more gothic, in that it has a crenellated roofline and a picturesque oriel window over the front door. It was altered from its original classical lines when the Broadway was widened in 1771. During the 1790s, the house was home to Benedictine nuns who had fled the French Revolution.

The Mayor, Councillor W.H. Jacob, opened the adjacent Abbey Gardens to the public in July 1890. The site was formerly that of the tenth-century Nunnaminster (the Nun's Minster), the nunnery begun by Ealhswith (also known as Alswitha), King Alfred's Queen. Archaeological excavations nearby have shown that the Nunnaminster was an impressive foundation and came to be a respected centre of learning. It stretched to what is now known as the Broadway and probably went as far south as Wolvesey Castle. The community of nuns living there were of the Benedictine order. After Alfred's death in 899, Ealhswith lived at the Nunnaminster and may have been its Abbess before her death in 902.

It was rebuilt in about AD 1100 and named St Mary's Abbey. It had a new church and surrounding it were the school, hospital and Abbess' lodgings, as well as the mill. The Nunnaminster was demolished in 1539 and the stones from the building were distributed for further building projects.

The statue of Queen Victoria, presently situated in the Great Hall, was moved to the Abbey Gardens in 1893. However, the great statue of King Alfred, erected in 1901 just a few yards away, was felt to overshadow that of the venerable Queen, and so she was moved back to the Great Hall in 1910.

The Abbey Gardens now feature the Soroptomists' Garden of the Senses, built by David Harber. Here you will find a stone monolith sundial.

OUTSIDE THE CITY

St Catherine's Hill

LESS THAN a mile outside Winchester's city centre is the majestic St Catherine's Hill, the 58-hectare chalk grassland site, once used as a point of navigation by Solent shipping. The land is owned by Winchester College and was, for many years, used by the college boys to play games and let off steam. It was also the site for WinCoFo (Winchester College Football).

The game adopted elements of both football and rugby and was played along the length of Kingsgate Street in the sixteenth century. It was rough and hard as there were no rules and it was literally a battle to get the overly inflated ball from one end of the street to the other.

It was later moved to St Catherine's Hill, as it was a safer place for the game to take place; there were no stray pedestrians to get in the way! Here, it was more difficult to keep the ball in play as the pitch, a flat rectangle, was at the apex of the sloping hillsides. The object of the game was to try to send the ball over the opponent's marker line (a cut into the turf known as 'worms'), to score a point. Junior boys were lined up along the edges of the pitch and were used as human walls to contain the ball and the players. Their position was dangerous, as they faced injury from fast moving footballs and from out of control players careering into them.

WinCoFo ceased to be played on the top of St Catherine's Hill in the 1860s and it is now played on purpose-built pitches at the college.

Today, the Hampshire and Isle of Wight Wildlife Trust manages the St Catherine's Hill site. The Tun Bridge car park is at the bottom of the hill, adjacent to the picturesque Itchen Navigation, just off Garnier Road. From here there is a superb view of the Hospital of St Cross a short distance away, across the water meadows.

By the car park is the old rail bridge, a relict of the Didcot, Newbury and Southampton Railway, which itself has a footpath along its top following the old railway track bed. There is a clearly marked path to follow, which takes the walker out into open land before the hill rises ahead. This land is interesting; it is the site of the old A33 ring road, which cut the hill off and made it a pretty island rising from the water meadows. When the M3 was built it

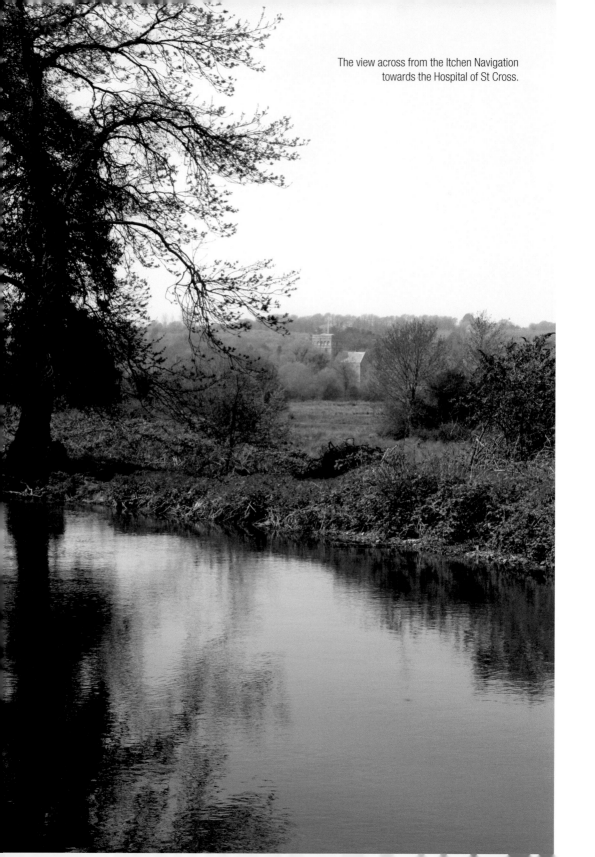
The view across from the Itchen Navigation towards the Hospital of St Cross.

remained marooned, but the old ring road was taken up and now, like the hill, it is host to a teeming multitude of wild flowers, insects and animals. The flat nature of the land though betrays the fact that it was once a road.

The walk up the hill is via 111 steps cut into the hillside, reached by following the clearly marked path contouring the hill. This gives increasingly good views of the city as you go higher.

At the top of the steps the ramparts of a circular Iron Age fort, built in 150 BC, are still visible. The path goes along the deep, hand-built Iron Age defensive ditch between two banks, which are still impressive in the third millennium after the fort was constructed. The original entrance is to the north-east. The hill fort was sacked in the first century and was then deserted.

On the edge of the beech trees at the top of the hill, which are a feature of the hilltop known locally as the Clump, are the remains of a Norman church, St Catherine's Chapel, buried in the ground. Dating from at least 1268, the chapel's name refers to the circular nature of the hill fort and to the trials of St Catherine at the hands of the pagan Romans. She was, so the story goes, a daughter of the pagan Crostus, an Alexandrian governor. She was laid on a wheel to be broken because she would not renounce her Christianity and had, instead, converted many to her faith, including the wife of the Emperor Maxentius. Such was her goodness that the wheel broke. Sadly for Catherine, the Romans were determined to get rid of the nuisance she had become and so she was then beheaded. However, instead of blood, milk flowed from her body, no doubt causing some consternation and puzzlement amongst her executioners. It is from St Catherine that we have the bonfire night Catherine wheel. St Catherine's Chapel was excavated in 1926, documented and then re-covered.

From the top of the hill the views are spectacular and it is possible to pick out major Winchester landmarks such as the Cathedral, the Hospital of St Cross, Winchester College and St Giles' Hill, the site of the huge medieval fair. In the fields between the hill and the city, looking down on the terrain, it is possible to see the dongas (the tracks through the land), worn from centuries of use by wagons and carts.

On the top of St Catherine's Hill is the 90ft by 86ft Mizmaze. This is a series of nine rounded-edge squares, described by Wendy Boase (1976) as 'cut by someone who did not understand the design'. The squares are cut into the chalk with raised grass banks, inches high, either side of the chalk path.

It is conjectured that the Mizmaze has been on St Catherine's Hill since medieval times and was re-cut at intervals. However, the information board at the site states that it is unlikely to have been cut prior to the seventeenth century. The earliest recorded mention of it is on a plan dated 1710. One story as to its origin says that a pupil at Winchester College, who was under punishment for a misdeed and was detained at the school over the Whitsun holiday, cut it to keep himself busy and pass the time. While doing this, he supposedly composed the school song, *Dulce Domun*. It is also said that the Church adopted the Mizmaze at one point and monks had to crawl along it on their knees as a form of penitence. The various false paths and dead ends were regarded as metaphors for the sins that had to be overcome on life's journey.

The 111 steps up St Catherine's Hill.
The view from the top is worth the climb!

The ditch from the Iron Age hill fort can still be seen.

The Mizmaze on St Catherine's Hill.

The St Catherine's Hill Mizmaze is open to the public and has been designed for followers to walk on the chalk, rather than the grass banks; it is more deeply cut into the landscape as people walk upon it. Of course, townsfolk walk it the traditional way, from the outside in, whereas traditionally Wykehamists walk it from the centre outwards!

St Giles' Hill

St Giles' Hill belonged to St Swithun's Priory. The annual three-day St Giles' fair, said to be the finest fair in England, was granted by William the Conqueror in 1096. Originally it was granted for the period of the vigil, feast and morrow of St Giles, 31 August to 2 September, but it grew in popularity and size. By 1200 it lasted more than a fortnight and had attracted European traders. Normal trading in the city, and for seven leagues around it, including Southampton, was suspended during the St Giles' fair, much, it can be inferred, to the inconvenience of local businesses.

The Bishop's representatives received the keys to the city from the Mayor and bailiffs. They went from gate to gate and surrendered the keys and proclaimed the fair. They then went to the hill in procession, whereupon the Bishop's officers were appointed for the fair's duration and the Mayor retired with his bailiffs. In effect, the Church took over the city for the entire time the fair ran.

The fair brought in huge amounts in terms of tolls exacted from the traders, who set up their stalls in rows according to their wares or nationality. Each of these rows was then named to reflect this. Thus there was the Fullers' Street, Wool Street, French Street and many others.

It was possible to buy all kinds of produce at St Giles' fair. The Winchester monks themselves sold drapery and spices. Wool was popular, as were lead and tin ingots from Cornish mines. Luxury items, like silks and gems from abroad, no doubt stoked the imaginations of the local folk, for whom a trip out of the city was a rarity. There was also livestock and more exotic animals, such as monkeys and peacocks.

The Bishop of Winton granted the fair at St Giles' Hill its Pie Poudre Court by permission of Edward IV (1442–1483).

Fairs were an important source of trade and entertainment to the local people and attracted jugglers, acrobats and various other performers. Some could earn no other living than to display their unfortunate physical imperfections. Fairs also attracted those bent on mischief, lured by the large crowds with full purses. To deal with those who were caught in foul play, a Pie Poudre Court was set up at each fair. The name derives from the French name for a vagabond, *pied poudreaux*, which literally means 'dusty foot' and is a reference to the tatty condition of the peddlers, who were the court's chief litigants.

The Pie Poudre Court dealt with all civil disputes at the market, as well as collecting tolls from traders and it had a reputation for the speed of its justice. Gradually, as the fairs declined, the Pie Poudre Courts became obsolete and the 1971 Courts of Justice Act took them off the statute books.

St Giles' fair also attracted highwaymen to the roads into the city. Here they would wait to waylay those with goods to trade or to relieve traders of their takings after the fair. King Edward I brought in the Statute of Westminster, which stipulated that there should be a 'bowshot' of land either side of the road, so that traders could see robbers coming.

The lookout at the top of St Giles' Hill.

The fair was never as popular again after the Black Death killed vast numbers across Europe. So many had been killed by the plague that it was difficult to keep the fair going. Local traders became more vocal about the need to cease business during the sixteen days of trading that the fair had progressed to. Henry VIII granted two further fairs, during Lent and on 13 and 14 October (Edward the Confessor's Day and the day after). This all combined to weaken St Giles' fair and it died out in about 1860 after being moved, first to the High Street and then to Bar End meadow.

The hill became a fashionable place for affluent folk to promenade. It offered splendid views of the east of the city and inspired brothers Samuel and Nathaniel Buck to engrave the scene as it was in their day, 1736. This engraving can be seen on the top of the hill today, in the wooden promontory that allows the visitor a commanding view of the vista below.

Part of the hill was bought by the Winchester City Corporation in 1878. The steps on the west side of the hill, along with the trees and the paths, all date from this time. Lord Northbrook, a member of the

Baring family (famed for its banking enterprises), donated further land some years later. Local architect Thomas Stopher, who was also Mayor of Winchester at this point in time, designed many of the houses built on the hill. St Giles' Hill is now a beautiful open space, fringed with woodland.

The Hospital of St Cross

Set beside abundant water meadows, with magnificent views of St Catherine's Hill, the Hospital of St Cross sits in ancient splendour. Bishop Henry de Blois, grandson of William the Conqueror and Bishop of Winchester from 1129–1173, founded the hospital in 1136. Its buildings span the period of 1150–1500. The Hospital of St Cross was a home for thirteen poor men and was, so it is said, built on the site of a religious building that had been laid waste by the Danes and left in ruins. The description 'hospital' was used as a term for 'hospitality'. Thus, the Hospital of St Cross was established as a new building giving aid to the poor.

The site also incorporated the Church of St Cross, which was not finished until the thirteenth century and thus spans the Norman and early English styles of architecture. It was added to over the coming centuries when windows, glass, the nave vault and chancel were added. The wooden cloister is Tudor.

The Almshouse of Nobel Poverty was added to the site in 1446, when Cardinal Beaufort, the son of John of Gaunt and Bishop of Winchester from 1404–47, for whom the tower is named, established the almshouse for high-ranking men who had fallen on hard times through no fault of their own. The Master's Garden is, like much

of the hospital, now open to the public at certain times and from here the view of the church across the pond is serenely beautiful.

Now both the Hospital of St Cross and the Almshouse of Noble Poverty are run under the same director, but it is easy to distinguish between the original poor men, the Blois Brethren, in their black gowns and the silver cross of the Knight's Hospitallers of St John, and the Beaufort Brethren in their dark red gowns, with the cardinal's badge in their trencher hats.

The twenty-five Brethren live rent-free in one-bedroom apartments in the fifteenth-century brothers' quarters; these are distinguishable by their imposingly high chimneys. They worship daily, in their respective gowns, and are expected to assist in some way with the running of the hospital. Thus, brothers guide visitors or help in the tearoom or the church. Upon being accepted into the Hospital of St Cross and Almshouse of Noble Poverty, and thus receiving their gowns, each has to declare: 'I will be no backbiter, whisperer, maker or favourer of those who make false reports, no causer of anger, hatred, discord, envy, reproach, strife or quarrel, but that I will endeavour to promote unity, peace and concord within its walls.'

The Brethren have come from all walks of life; the main criterion for entry is that their means are slender. Frederick William Speak, gowned in 1937, was the private secretary to four successive Bishops of Winchester. He died in 1940 and is buried in the St Cross churchyard. Alfred Robinson, gowned in 1957, worked in the Royal Hotel in Winchester. He had served in the Royal North Lancashire Regiment during the First World War, earning the Military Cross and the rank of Captain as he went.

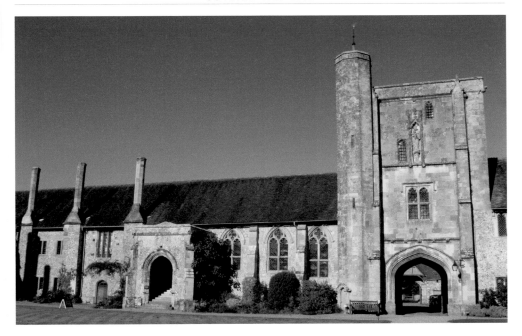

The Beaufort tower and the brothers' quarters.

Originally, the hospital provided free meals for a hundred poor people. This figure was increased to 200 later. Each recipient received nearly three pounds of coarse bread, a bowl of hearty soup, two eggs or meat or fish and three quarts of small (weak) beer. Thirteen of those in direst need also received lodging and supper: a loaf of wheat bread, a gallon and a half of small beer and soup, and a three-course dinner every day. The Charter of Foundation sets out in some detail the conditions of the chosen thirteen; according to this they should be 'feeble and so reduced in strength that they can scarcely, or not at all, support themselves without other aid.'

Over time the dole was threatened by corruption or incompetence. The Master of the Hospital, whose nineteenth-century flint-faced lodge sits just outside the main gates, was in charge of the finances. In the

fifteenth century, William of Wykeham had to step in to regulate the hospital's revenues. The abuse of a clause in the hospital's 1696 statutes, which said that the Master could claim any surplus after he had discharged his dues, caused further suffering in the eighteenth century when the Hon. Brownlow North (1741–1820) was appointed Bishop of Winchester by his half-brother, Lord North, the Prime Minister. He in turn appointed his son, Francis, later the Earl of Guildford, as the Master of St Cross. Francis was forced to resign from this post after nearly fifty years, when Reverend Harold Holloway leaked news of his wholesale embezzlement and neglect of the hospital to the press. The legal action that followed also led to bankruptcy for the hospital. Trusteeship of the hospital's funds began properly in the nineteenth century, after much public goodwill in replacing funds.

In the late nineteenth century there was again debate about the finances of the hospital. Barbara Carpenter Turner (1979) notes that there was concern in 1880 because there were no 'red' brothers and councillors were finding it difficult to define what a 'noble pauper' actually was. It was also noted at that time that the annual income for the hospital was £3,330 a year.

Today, visitors can request the Wayfarers Dole at the Porter's Gate. This is a piece of bread and a small amount of ale; thus the tradition is kept alive.

The Hospital of St Cross displays its old kitchens and the cellar, as well as the Brethren's Hall (the communal dining room), to visitors.

The Hospital

Winchester had the first recognisable general hospital outside London, opened in October 1736. Its founder, Cathedral canon Dr Alured Clarke, originally sited it on the corner of Colnbrook Street. The hospital was based on St George's Hospital in Hyde Park, London. There were detailed rules laid down for its management, accounts were properly run, standards were monitored, doctors visited once a week and the apothecary had charge of the patients' diets as well as their medication. The hospital was run by subscription, as a form of private health care, and it did not treat infectious illnesses or cater for women in childbirth, although it did have a venereal disease section. This hospital building survived until 1959, when it was demolished. Timbers found at that time, bearing biblical inscriptions, are now in the City Museum.

The hospital moved to larger premises in Parchment Street in 1756. This later

caused problems when the hospital cesspit overflowed into Upper Brook Street, exacerbating a city-wide drainage and sewerage problem. A new pumping station erected in Garnier Road eventually solved Winchester's drainage problems, but not until after an outbreak of typhoid at Winchester College killed a boy in 1874.

The solution for Winchester's hospital was to move opposite the prison, on Romsey Road. Florence Nightingale is said to have believed that the West Hill was a healthier site for the hospital. Today, this is the Royal Hampshire County Hospital. The hospital was designed from plans penned by Nightingale, which were interpreted by William Butterfield (1814–1900). He favoured the gothic style and is remembered today for many of the churches he specialised in designing. He designed Balliol College Chapel and Keble College in Oxford. The hospital was built in 1864 and is still going strong today. It has been added to with extensions and outbuildings, so the site incorporates a hybrid of styles, but the Victorian structure is still central to the hospital. A maternity unit was opened in 1973.

Winchester Community Prison

The prison was built in 1846–49 on a central axis with five spokes; one for offices and four for the inmates. In the middle is a raised turret. It is a male closed Category B prison, meaning that the prisoners held there are unlikely to try to escape, but that security levels make it difficult for them to do so.

It was originally built by Charles J. Pierce, who had worked on the design of Pentonville Prison, but the work did not

The Royal Hampshire Hospital.

go well and Thomas Stopher Sr replaced Pierce and finished the project. Prisoners from the Jewry Street gaol and from the Bridewells in Winchester, Southampton, Portsmouth and Gosport were transferred to the new prison during late 1849.

The prison was designed to utilise natural light; there were skylights built into the pitched roof and large windows set into the walls at the ends of the wings. The prison had its own 217ft-deep well. It was also supplied with a treadmill, capable of taking forty-eight prisoners at one time, and an adjustable hand crank; the degree of difficulty of turning this could be regulated by the prison officers with a screw, hence the derogatory term now used for prison officers by inmates.

In 1871, the average daily prison population was 316 (both male and female prisoners). By 1899 this had risen to 345. In 2004 there were 555 in the main prison and

82 in West Hill. At the time it was reported to be fifty per cent overcrowded.

There have since been several additional buildings added to the site, most notably the 1908 hospital and the 1964 Remand Centre. The Annex, built in 1963, was first used as a young offenders centre and is now known as the West Hill Wing. It housed female prisoners from 1995, when the first female inmates for sixty years arrived at the jail, until 2003, when the unit became the Democratic Therapy Unit for women prisoners. From February 2004 it changed again and is now a Category C Male Resettlement Unit.

The first public execution was of Abraham Baker in 1856. The scaffolding for public hangings was built over the front entrance to the prison. The last public execution held at Winchester was in 1867, of solicitor's clerk Frederick Baker, for the

grisly murder of little Fanny Adams (1859–1867) in Alton, in August that year.

Serial killer Rosemary West was held in a separate unit within Winchester Community Prison in 1995, while on trial on ten counts of murder. Animal rights activist Keith Mann was also an inmate at the prison in the mid 1990s.

Winchester Prison featured in Stanley Kubrick's *A Clockwork Orange* in 1971, and Thomas Hardy's 1891 novel *Tess of the D'Urbevilles* tells of the luckless Tess, who is imprisoned and ultimately executed in 'Wintoncester' jail.

Next door stood the 1847 County Police headquarters, in an imposing ivy-clad building, resembling a Victorian country house. This was superseded by the eight-storey utilitarian office block that is the County Police headquarters today. The county architect H. Benson Ansell, who designed the impressive Rotunda at the Winchester School of Art in 1962, also designed the new headquarters, which was built in 1962–65.

In 2008, approval was granted to buy Alpha Park in Eastleigh, to develop into a new Hampshire Constabulary headquarters complex. However, due to recession and the consequential cut-backs, the land is yet to be developed.

St James' Catholic Cemetery

Saint James' Catholic Cemetery is so tiny it is very easy to miss. It is diagonally opposite the Hampshire Constabulary grounds, and just along from the walls of the water tower. This peaceful, elevated spot beside the busy main road provides a fascinating glimpse into the more practical side of life and death in Winchester during turbulent times. If you were a Catholic in a Protestant country, where all the churches and their churchyards had either been destroyed or converted to the new religion, where were you buried when your time came?

The graveyard was attached to a Saxon church, which makes it one of only three such churches recorded for the Middle Ages. The plague wiped out the parish and, in 1396, the Pope decreed it closed. Its wealth was later diverted to the Hospital of St Cross. The church was demolished during Elizabeth I's reign, though the graveyard remained, which was useful when, in 1589, the Catholic Nicholas Tichborne died in Winchester prison.

The home of the Hampshire Constabulary.

The view down Romsey Road towards Elizabeth II Court.

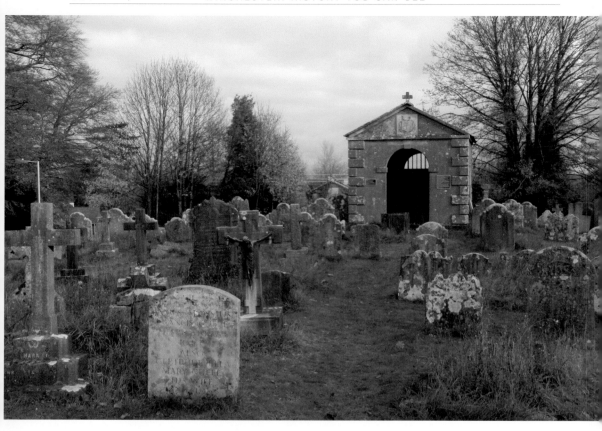

The churchyard at St James' Catholic Church.

He had been imprisoned for his faith and on his death was buried in the old graveyard. Other Catholics buried here include Nicolas' cousin, Gilbert, who died aged 96 and had lived through the reigns of six monarchs, beginning with Henry VIII.

The graveyard can be accessed via steps by the Gatekeepers' Lodge on Romsey Road, and then through gates that open onto the small sea of well-kept headstones and markers. Many of the people buried here were Roman Catholic clergy, their families, prisoners, French refugee priests and even members of the nobility. In the centre of the graveyard is a mausoleum dedicated to the Constable family, who were descended from the Smith family; they were trustees of St Peter's Parish until 1800. In 1801 the graveyard was sold to the Catholic London District and St Peter's Parish for £42.

Walking back from St James' Catholic Cemetery down Romsey Road, towards the city, there is a stunning view of the clock tower in Elizabeth II Court and of the city's roof tops; this completes a picture of Winchester: History You Can See.

BIBLIOGRAPHY

Books

Badcock, C. & Frank, E., *Winchester* (The Pevensey Press, Cambridge, 1988)

Ball, A., *Winchester Illustrated: The City's Heritage in Prints & Drawings* (Halsgrove, 1999)

Biddle, M., *The Study of Winchester: Archeology and History in a British Town* (The British Academy, 1984)

Blore, G.H., *The Monuments of Winchester Cathedral* (Saint Michael's Abbey Press, 1983)

Boase, W., *The Folklore of Hampshire and the Isle of Wight* (Batsford, London, 1976)

Brown, J., *Southampton Murder Victims* (Derby Books Publishing, 2010)

Bullen, M., Crook, J., Hubbuck, R. & Pevsner, N., *Hampshire: Winchester and the North* (Yale University Press, 2010)

Bussby, F., *William Walker: The Diver who Saved Winchester Cathedral* (The Friends of Winchester Cathedral, 1970)

Bussby, F., *Winchester Cathedral 1079–1979* (Paul Cave Publications, 1979)

Carpenter Turner, B., *Winchester 100 Years Ago* (Paul Cave Publications, 1979)

Carpenter Turner, B., *Winchester* (Paul Cave Publications, 1980)

Carpenter Turner, B., *A History of Winchester* (Phillimore, 1992)

Carpenter Turner, B., *St John's Winchester Charity* (Phillimore, 1992)

Cecil, D., *A Portrait of Jane Austen* (Penguin Books, London, 1978)

Crook, J., *The Wainscot Book* (Hampshire County Council, 1984)

Crook, J., *Winchester Cathedral: Nine Hundred Years* (Phillimore, 1993)

Davey, C. R., *The Hampshire Lay Subsidy Rolls, 1586* (Hampshire County Council, 1981)

Dick-Read, S., *Winchester in Old Picture Postcards* (European Library, 1993)

Dom, S.F. & Hockey, F.R., *The Register of William Edington Bishop of Winchester 1346–1399: Part 1* (Hampshire Record Office for Hampshire County Council, 1986)

Donovan, C., *The Winchester Bible* (The British Library and Winchester Cathedral Enterprises, 1993)

Freeman, J.D.F., Jowitt, R.E. & Murphy, R.J., *King Alfred Motor Services: The Story of a Winchester Family Business* (Kingfisher Railway Productions, 1984)

Greatrex, J., *The Register of the Common Seal* (Hampshire County Council, 1979)

Haney, K. E., *The Winchester Psalte: an Iconographic Study* (Leicester University Press, 1986)

Henderson, I. & Crook, J., *The Winchester Diver: The Saving of a Great Cathedral* (Henderson and Stirk, 1984)

James, T.B., *Winchester: A Pictorial History* (Phillimore, 1993)

Jenkins, E., *Jane Austen* (Victor Gollancz, 1973)

Jennet, S., *The Pilgrims' Way* (Cassell, 1971)

Kilby, P., *Winchester: An Architect's View* (WIT Press, Southampton, 2002)

Lee, S. & Stephen, L., 'Alice Lisle's Article', *British Dictionary of National Biography* (Oxford University Press, 1997)

Millson, C., *Tales of Old Hampshire* (Countryside Books, 1980)

Page, M., *The Pipe Roll of the Bishopric of Winchester 1301–2* (Hampshire County Council, 1996)

Robertson, K., *The Railways of Winchester* (Platform 5 Publishing, 1988)

Shurlock, B., *The Winchester Story* (Milestone Publications, 1986)

Stanning, J., *Pictures and Glass in St Lawrence Church, Winchester* (2009)

Stevens, P. & Dine, D., *Winchester Seen and Remembered* (Hampshire County Library, 1978)

Thorn, J., *Road to Winchester* (Weidenfeld and Nicolson, 1989)

Vaughan, J., *The Medieval Chantries of Winchester* (Winchester Cathedral Publications, 1977)

Wareham, J., *Three Palaces of the Bishops of Winchester* (English Heritage, 2000)

Websites

1911: www.1911encyclopedia.org

ADS: www.ads.ahds.ac.uk

AQSM: www.aqsm79.dsl.pipex.com

Archiseek: www.archiseek.com

Astoft: www.astoft.co.uk

Barbara Hepworth: www.barbarahepworth.org.uk

BBC News: www.bbc.co.uk/news

Britain Express: www.britainexpress.com

Britannia: www.britannia.com

British Cemetery: www.british-cemetery-elvas.org

British Civil Wars: www.british-civil-wars.co.uk

British History: www.british-history.ac.uk

British Prisons: www.british-prisons.co.uk

Brit Royals: www.britroyals.com

Building 4 Change: www.building4change.com

Chesil Theatre: www.chesiltheatre.org.uk

City of Winchester: www.cityofwinchester.co.uk

City of Winchester Trust: www.cwt.hampshire.org.uk

Daily Echo: www.dailyecho.co.uk

Draw, Paint, Sculpt: www.drawpaintsculpt.com

Forge Robinson: www.forgerobinson.com

Friends of King Alfred buses: www.s262662507.websitehome.co.uk

Hampshire: www.hampshire.greatbritishlife.co.uk

Hampshire Chronicle: www.hampshirechronicle.co.uk

Hampshire Constabulary: www.hampshire.police.uk

Hampshire County Council: www3.hants.gov.uk

Hampshire Wildlife Trust: www.hwt.org.uk

Hampshire Fire & Rescue Service: www.hantsfire.gov.uk

Heretical: www.heretical.com

Horsepower: www.horsepowermuseum.co.uk

Huw Thomas: www.huwthomasarchitects.co.uk

Hyde 900: www.hyde900.org.uk

Independent: www.independent.co.uk

Justice: www.justice.gov.uk

Live heritage Initiative: www.lhi.org.uk

Megalithic: www.megalithic.co.uk

Molesey History: www.moleseyhistory.co.uk

Nashford Publishing: www.nashfordpublishing.co.uk

National Trust: www.nationaltrust.org.uk

Oxford: http: www.oxforddnb.com

Paul Halsall: www.fordham.edu

Peter Freeman: www.peterfreeman.co.uk

Peter Gould: www.petergould.co.uk

Public Property: www.publicpropertyuk.com

Queen Emma: www.queenemmas.co.uk

Rachel Fenner: www.rachelfenner.co.uk

Royal Green Jackets: www.rgjmuseum.co.uk

RSA: www.rsagroup.com

Scottish Architects: www.scottisharchitects.org.uk

Sculpture: www.sculpture.org.uk

Serle's House: www.serleshouse.co.uk

Society: www.c20society.org.uk

The Best of: www.thebestof.co.uk

The Gurkhas: www.thegurkhamuseum.co.uk

Victorian Web: www.victorianweb.org

Visit Winchester: www.visitwinchester.co.uk

Weeke Local History: www.weekehistory.co.uk

Wikipedia: www.en.wikipedia.org

Winchester: www.winchester.gov.uk

Winchester College: www.winchestercollege.org

Winchester Morris Men: www.winchester-morris-men.org.uk

Winchester University: www.winchester.ac.uk

Other titles published by The History Press

Hampshire Past & Present
RUPERT MATTHEWS

Hampshire Past & Present contrasts a selection of 100 old photographs alongside modern ones taken from similar locations, to demonstrate the changes that have occurred in a scene over the intervening years. Fascinating images of city centres, housing, shops, and people at work and play bring Hampshire's history to life. It is a captivating insight into the changes and developments that have taken place over the years, and an enjoyable read from cover to cover.

978 0 7524 5816 8

Hanged at Winchester
STEVE FIELDING

For decades the high walls of Winchester Prison have contained some of the country's most infamous criminals. Until hanging was abolished in the 1960s it was also the main centre of execution for those convicted in Hampshire. Fully illustrated with photographs, news cuttings and engravings, *Hanged at Winchester* features each of the cases in one volume for the first time and is sure to appeal to everyone interested in the shadier side of Hampshire's history.

978 0 7524 5707 9

Folklore of Hampshire
PENNY LEGG

Folklore of Hampshire reveals the rich heritage of the county's traditions, seasonal customs, saints' lore, hill figures, holy wells and songs. From Abbotts Ann and the 'Maiden's Garlands' through to St Swithin's forty days of rain, the Tichborne Dole and the 200-year-old 'Knighthood of Southampton Old Green Championship', this book looks at the county as never before. With an intriguing selection of images, the origins and meanings of Hampshire's traditions are explored to create a sense of how the customs of the past have influenced the present.

978 0 7524 5179 4

A Grim Almanac of Hampshire
JOHN VAN DER KISTE

A Grim Almanac of Hampshire is a day-by-day catalogue of 366 ghastly tales from the county's past, full of dreadful deeds, macabre deaths, grisly accidents and strange occurrences. Among the gruesome tales included are the sinking of the Mary Rose, King Henry VIII's flagship, in 1545 with the loss of almost 700 men; the story of Dame Alice Lisle, executed in 1685, whose ghost is said to haunt the lanes around her home at Ringwood; and of the double murder of Lydia and Norma Leakey in the New Forest in 1956. If you have the stomach for it, then read on...

978 0 7524 5489 4

Visit our website and discover thousands of other History Press books.

www.thehistorypress.co.uk